SOCCER
IN ONEONTA

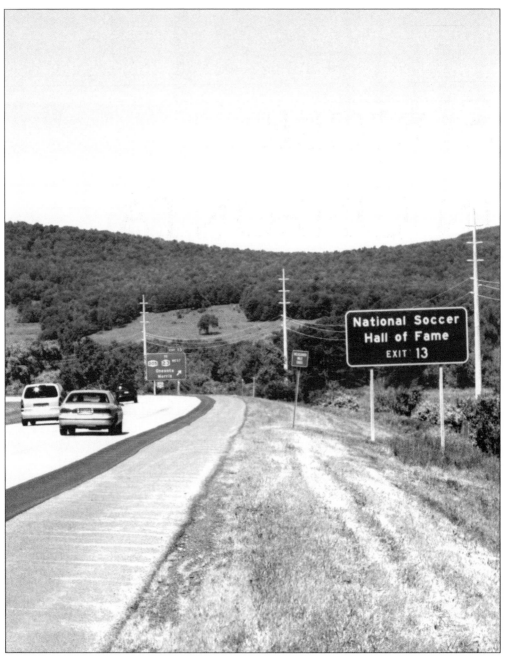

A POINT OF DESTINATION. Since 1979, the National Soccer Hall of Fame has housed an extensive archive of memorabilia associated with soccer in the United States. Founded in Oneonta, New York, the Hall of Fame is an organization committed to preserving the history and sport of soccer in the United States. The Soccer Hall of Fame is a partner with six other regional museums, comprising the Tourism Trail in New York.

SOCCER
IN ONEONTA

Mark Simonson

ARCADIA

First published 2004

Published by Arcadia Publishing,
Charleston SC, Chicago IL, Portsmouth NH, San Francisco CA

Printed in Great Britain

Library of Congress Catalog Card Number: 2004107271

For all general information, contact Arcadia Publishing:
Telephone 843-853-2070
Fax 843-853-0044
E-mail sales@arcadiapublishing.com
For customer service and orders:
Toll-free 1-888-313-2665

Visit us on the Internet at www.arcadiapublishing.com

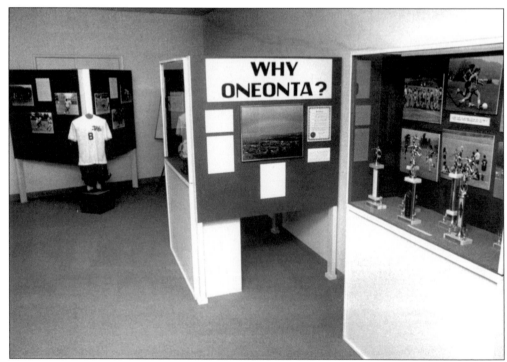

A FREQUENTLY ASKED QUESTION. Whether people have questions about the Soccer Hall of Fame locating in Oneonta, or how the game became so popular since the 1950s, a visitor to the museum, seen here in the early 1980s, learns just how it all happened. (Courtesy of the National Soccer Hall of Fame.)

CONTENTS

ACKNOWLEDGMENTS

When the idea of a pictorial history of soccer in Oneonta was proposed, it was warmly greeted by the National Soccer Hall of Fame, the State University College at Oneonta, Hartwick College, Oneonta High School, and the many people who created the Oneonta Youth Soccer Program. These institutions and many individuals were very gracious and helpful in allowing me to look through their archives.

A round of very special thank-yous is due to the following for their consultation in choosing the book's images: Peg Brown, Jack Huckel, and the rest of the staff at the Soccer Hall of Fame; Shelley Wallace, Rob Clark, and Mike Chilson at Hartwick College; Geoff Hassard, Carol Blazina, and Mary Lynn Bensen at Oneonta State; Joe Hughes at Oneonta High School. Dan Swift and the *Daily Star* are also notable contributors. Many other individuals were most generous with personal collections, including David Brenner, Gerry Raymonda, the Ranieris, and Nelson DuBois.

Although I grew up with soccer in Oneonta, there was a lot of information I was not aware of until embarking upon this project. Informative interviews and conversations took place with Oneonta State coaches Garth Stam and Tracey Ranieri, Ed Clough from Hartwick College, Tony Drago, Alex Brannan, and Helen Sandford from Oneonta High School, along with key people in the development of the Soccer Hall of Fame, and the hall's historian Colin Jose.

INTRODUCTION

A simple answer to the question about why the National Soccer Hall of Fame is located in Oneonta is because of college soccer at Oneonta State and Hartwick College, a good program at Oneonta High School, and the fact that the National Baseball Hall of Fame and Museum is located in nearby Cooperstown.

Oneonta has been influenced by its neighbor and the tourism it generates for the region. Cooperstown may not be the birthplace of baseball, but it is without question the birthplace of the Hall of Fame phenomenon. While Oneonta State has a competitive and well-supported soccer program, including a Division III Women's National Championship in 2003, Hartwick College, frequently a national contender in collegiate soccer, cemented its place in history by capturing the 1977 NCAA Division I Men's National Championship. The celebration resonated through the city of Oneonta, and amidst the clamor, someone asked, "Where is the National Soccer Hall of Fame?"

No one knows for sure, but that someone might have been city of Oneonta parks and recreation director Albert Colone, or local Hartwick soccer fans John Biggs, Bill Atchinson, or Jim Ross—all founding Hall of Fame board members. Oneonta mayor James Lettis appointed Colone to lead a task force to find the answer. The answer was that a hall existed, primarily in storage at a soccer club in Philadelphia. The group responded in the spirit of Robert F. Kennedy: "Some see things as they are and wonder why. I dream of things as they never were and ask why not?"

The rest is history. The residents of Oneonta, including such leading citizens as Jane DesGrange, Margaret Lunn, Peter Dokuchitz, and Barbara Ross, pitched in. The living Hall of Famers were tracked down, and memorabilia, artifacts, and collections were acquired. A library was started. Although many assisted, the future of the Hall of Fame was primarily in the hands of one man, Albert Colone, who successfully built the organization and served as the executive director for the next 20 years. The archive grew into the largest collection in the world.

From the first exhibit in Dewar Hall at Hartwick College in 1979, these citizens had a vision for a prominent Soccer Hall of Fame and began petitioning the U.S. Soccer Federation for its sanction. Hall of Famers, excited that Oneonta was committed to honoring soccer and its history, lent their support for the drive for recognition. A newsletter was produced in 1980, and for the first time, America's soccer heroes had a voice. In March 1981, the Wilber Mansion on Ford Avenue became home to the country's first National Soccer Museum. By December 1981, Oneonta declared itself the home of the National Soccer Hall of Fame.

Despite challenges from larger metropolitan areas, the evidence that Oneonta had established a museum, registered the trademarks, acquired the collections, and most importantly, garnered the support of the Hall of Famers themselves won the day. At its general meeting in 1983, the U.S. Soccer Federation adopted a resolution sanctioning Oneonta as the official National Soccer Hall of Fame and Museum for the sport in the United States.

In 1987, Wilber National Bank assisted the Hall of Fame in establishing a 4,000-square-foot interim museum. It opened adjacent to the bank on Ford Avenue and served as their home for the next 12 years. In 1989, thanks to the generosity of Clyde and Brian Wright, and the insight of D. K. Lifgren, a 61-acre plot was purchased, and development began for four state-of-the-art fields on the Hall of Fame's new campus.

On June 12, 1999, the vision of unifying the museum and the fields was realized with the dedication of the grand facilities. The dreams of the founders, their followers, and the city of Oneonta had been advanced by a new generation of builders led by Hall of Fame chairman Doug Willies and board members Bill Atchinson, Gene Bettiol Jr., Scott Clark, Sandi Collins, Alan Donovan, Joe Forgiano, Karen Lewis, Tracey Ranieri, Phil Wilder, Brian Wright, and Hall of Fame president and CEO Will Lunn.

The name Oneonta and the legacy of its soccer tradition have been taken to the four corners of the world by many who once called (or still do call) "the City of the Hills" home. The careers of those individuals have been part of the fabric and history of the development of soccer in the United States.

Of those mentioned, many have played or coached professional soccer both here and abroad. The Oneonta Connection includes the commissioner of Major League Soccer (MLS), national and Olympic coaches, and a member of the board of directors of U.S. Soccer, to name a few.

Oddly enough, the game of competitive soccer arrived in Oneonta as recently as the mid-1950s. Before that, it was played locally by many rural area schools. College and high school teams kept improving in their skills and winning more games and eventually state and national championships. Youth soccer became popular in the late 1960s. The city adopted a nickname, Soccertown, USA.

Why Oneonta? A few dreamers asked "why not?" and the rest is history.

One

LATE TO ARRIVE
IN ONEONTA

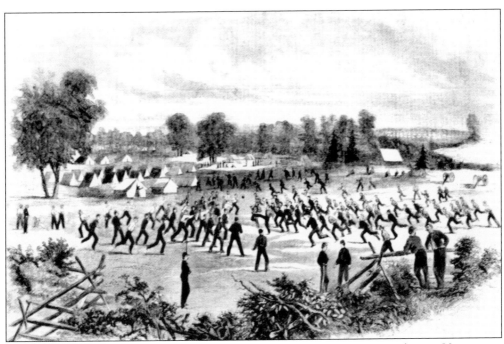

EARLY AMERICAN SOCCER. This image depicts Camp Johnson, near Winchester, Virginia, as the first Maryland regiment plays foot-ball before an evening parade. Soccer has been a part of our sporting life for centuries. On the broad beaches of Massachusetts, colonists watched Native Americans play a running and booting contest with a deerskin ball. Newcomers from the British Isles brought their own brand of football to these shores. (Courtesy of the National Soccer Hall of Fame.)

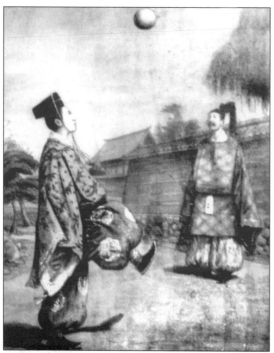

EARLIEST KNOWN SOCCER. This was a game called *Kemari*, played in Japan *c.* 600 B.C. It was close to modern soccer. By 300 B.C., the goalposts had been standardized as bamboo stakes 15 feet high. An even earlier game, *Tsu Chu*, was played in China *c.* 2500 B.C. Balls made of animal skin were kicked through a hole in a net stretched between two poles 30 feet high. (Courtesy of the National Soccer Hall of Fame.)

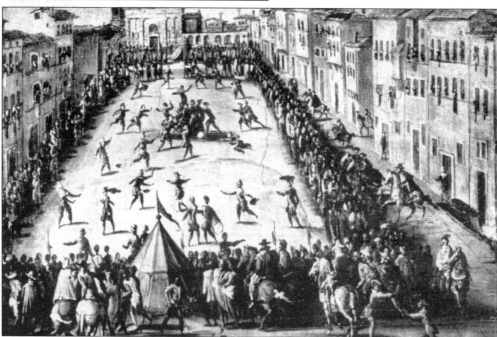

THE GAME OF CALCIO. In another game similar to modern soccer, there were 26 players per side, and the idea was to kick, pass, or carry the ball across the goal. An Italian account of the game was written in 1520, and 31 years later an English schoolmaster mentioned *Calcio*, as well as its similarity to English football, in a treatise on the education of the young. In 1580, Giovanni Bardi codified the rules in the manual *Discorsa Calcio*. (Courtesy of the National Soccer Hall of Fame.)

MAKING HISTORY. Gerritt Smith Miller, at age 18, was the originator and captain of the Oneida Football Club. Founded in 1862, it is the first known soccer club in the United States. The Oneidas were undefeated from 1862 to 1865. A monument now stands in Boston Common, where the Oneidas played their home matches. (Courtesy of the National Soccer Hall of Fame.)

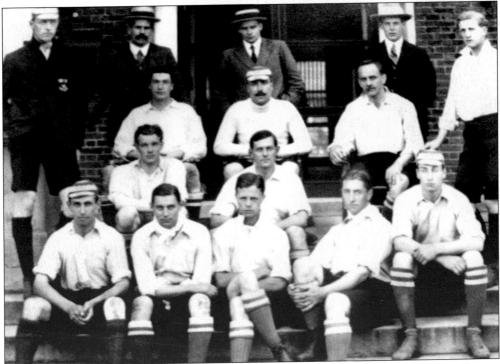

THE COLLEGE GAME. Before the 1860s, football rules varied from college to college. But on November 6, 1869, Rutgers defeated Princeton 6-4 in the nation's first intercollegiate match played under a close facsimile of the rules codified by the Football Association of England. Shown in this *c.* 1905–1906 photograph is the University of Pennsylvania soccer team. (Courtesy of the National Soccer Hall of Fame.)

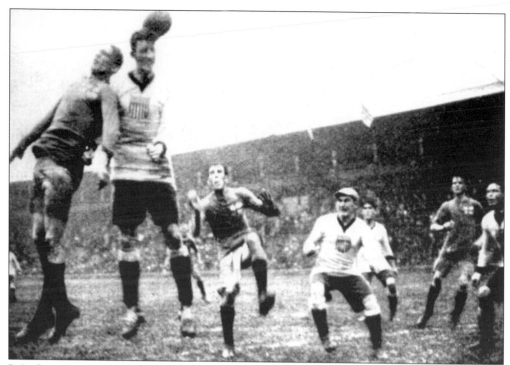

IT'S OFFICIAL. While the United States had fielded teams as early as 1885, the first national team under the auspices of the U.S. Football Association traveled to Scandinavia in 1916. Their matches included full internationals against Sweden and Norway. Shown here, the All-American team is in action during its 3-2 win over Sweden. (Courtesy of the National Soccer Hall of Fame.)

PLAYING BY THE RULES. The American Football Association was organized in Newark, New Jersey, uniting the numerous metropolitan area enclaves of the East to maintain uniformity in the interpretation of rules and provide an orderly and stable growth of soccer in America. This guide was used to teach rules to newcomers of the game. (Courtesy of the National Soccer Hall of Fame.)

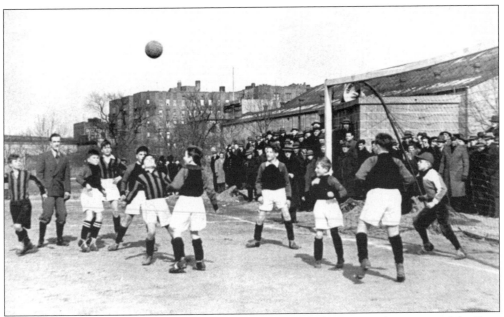

A CITY GAME. Thousands of British immigrants arrived in the metropolitan areas of the East, Midwest, and Pacific coast. Communities with textile mills, shipyards, quarries, or mines also had soccer teams among their immigrant population, a pattern occurring all over the world during the time of the industrial revolution. Younger children also took up the game, as seen here. (Courtesy of the National Soccer Hall of Fame.)

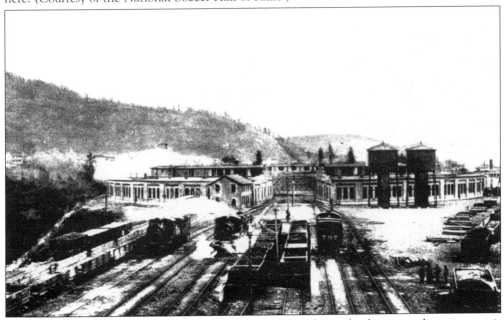

NO SOCCER IN ONEONTA. Even though Oneonta had its share of industries and immigrants, it was not until the 1950s that organized soccer began here. The Delaware and Hudson Railroad was Oneonta's primary industry, and immigrants from Italy, Ireland, Lebanon, Poland, and Russia came to Oneonta for jobs. Seen here is the largest roundhouse in the world in the rail yards, a distinction it held from 1906 to 1915.

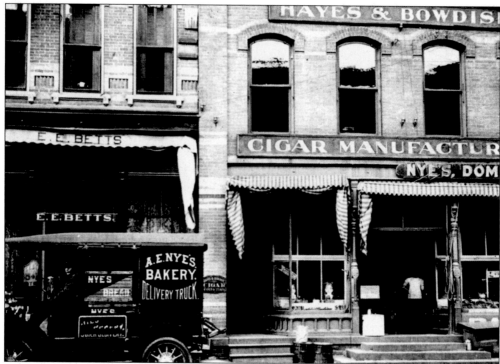

OTHER INDUSTRIES IN ONEONTA. Cigar making (above) was second behind the railroad as a leading employer. Hayes and Bowdish, and Doyle and Smith were leading manufacturers in their buildings along Main and Broad Streets. From the days of the first settlement, saw and grist milling (below) were common businesses. A Chicago family named Elmore owned this mill, located along lower Main Street. Cigar manufacturing lasted until the 1930s, and a more modern mill on this site closed in 1963. Whether employees worked at the cigar manufacturers, mills, or the railroad, they preferred sports such as baseball, basketball, and American football.

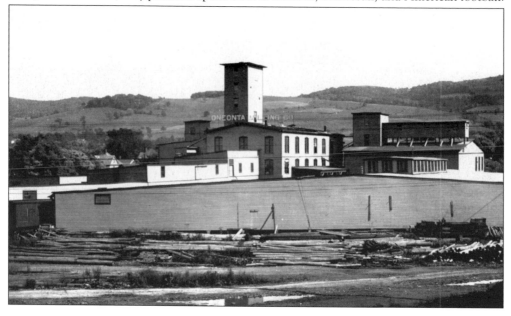

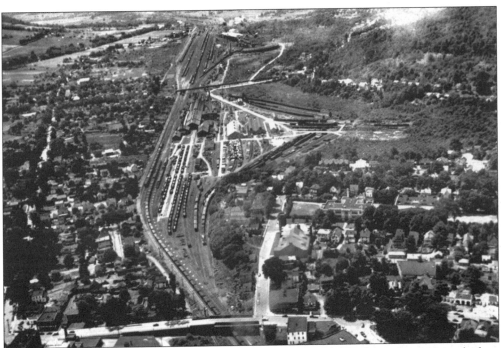

THE DECLINE OF THE RAILROAD. Around the time of World War I, employment peaked on the Delaware and Hudson Railroad at nearly 1,800, or about 40 percent of the city's labor force. After World War II, the diesel engine was introduced, and within a few years the massive roundhouse, which once repaired all locomotives, was no longer needed and closed. The shops in the Delaware and Hudson rail yards closed for good in early 1996.

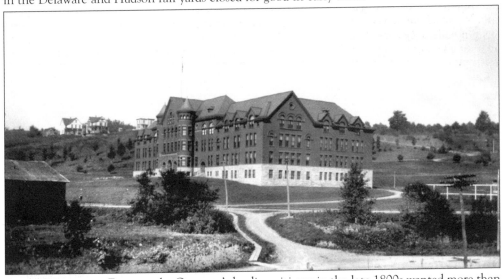

GOOD FORESIGHT. Fortunately, Oneonta's leading citizens in the late 1800s wanted more than just industry to employ people in the city. They succeeded and brought the Oneonta Normal School to the city, which was the beginning of today's State University College at Oneonta. This building, known as Old Main, was erected in 1894, replacing a similar structure that was built in 1889 but was destroyed by fire. (Courtesy of the James M. Milne Library Archives at SUNY-Oneonta.)

A GROWING COLLEGE. After World War II, the college, then known as the Oneonta State Teachers College, had a surge in enrollment from veterans of the war, as they were promised an education through the G.I. Bill of Rights. Seen here is Charles Hunt, college president, at a groundbreaking in 1948 for an expanded campus on the hillside above Old Main. (Courtesy of Mrs. Frances Green.)

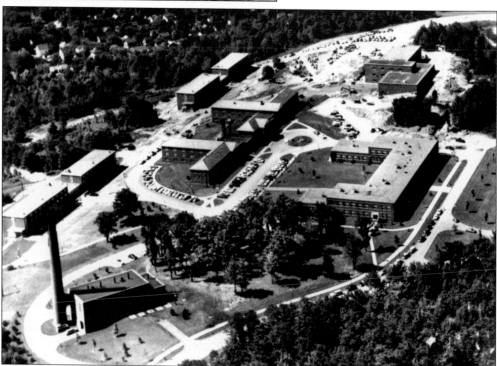

ONEONTA STATE, C. 1955. Construction of a heating plant, home economics building, and three dormitories finally got under way in 1951. Unexpected delays prevented completion until 1954. With a much larger student body, new sports were introduced, and it was only a matter of time before soccer arrived as a competitive sport at Oneonta State.

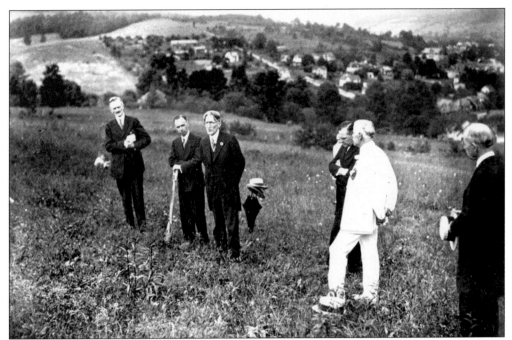

ANOTHER COLLEGE ARRIVED IN 1928. Groundbreaking ceremonies took place on June 26 for the new Hartwick College. It was originally located near Cooperstown and was known as Hartwick Seminary. Seen in this photograph are, from left to right, the following: Robert J. VanDeusen (college field representative), Dwight J. Baum (architect), Charles Leitzell (board of trustees president), Charles Myers (college president), Abraham L. Kellogg (trustee and benefactor), and Arthur Seybolt (trustee and college attorney). (Courtesy of the Paul F. Cooper Jr. Archives at Hartwick College.)

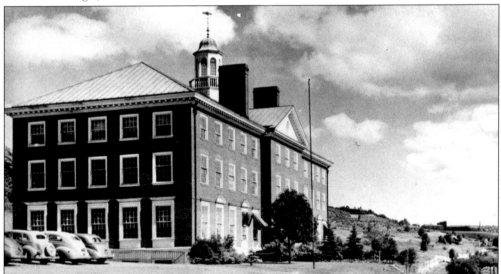

HARTWICK COLLEGE'S FIRST BUILDING. Known originally as Science Hall and later renamed Bresee Hall, this building opened for classes in 1929. Classes were temporarily held at the former Walling Mansion on Main Street, the site of today's United Presbyterian Church, commonly referred to as "the Red Door Church."

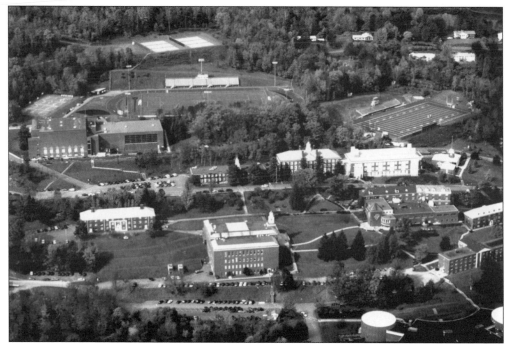

MAJOR EXPANSION. Just like its neighboring college on another hill, Hartwick saw enormous growth after World War II, which lasted well into the 1960s and early 1970s. Both Hartwick and Oneonta State had fielded traditional American sports, such as football, baseball, and basketball, over their history. But that all changed at Hartwick in the mid-1950s. (Courtesy of the Paul F. Cooper Jr. Archives at Hartwick College.)

ONEONTA IS ACCESSIBLE. Oneonta's economy now centers primarily on tourism, education, and healthcare. With the construction of Interstate 88 in the 1970s, the city became very accessible for students, and more so for tourists. Oneonta and its National Soccer Hall of Fame are part of the Tourism Trail in New York. It joins such popular attractions as Howe Caverns, the Baseball Hall of Fame, the Northeast Classic Car Museum, Museum of the Earth, the Corning Museum of Glass, and the Rockwell Museum.

Two
ONEONTA STATE SOCCER

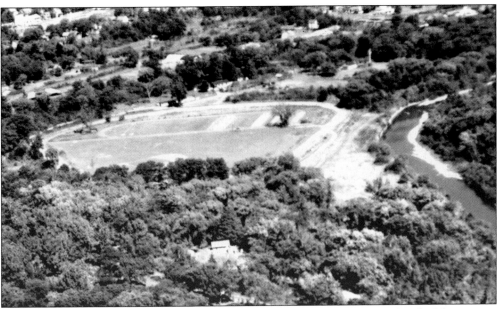

WEBB ISLAND. This was an all-purpose type of field, where horses were raced and athletic teams from the high school and colleges practiced for a wide variety of sports. Since Oneonta State did not have an athletic field for its new soccer team in the mid-1950s, the Red Dragons played the first few seasons here. Webb Island is located in the same area where Catella Park is found today. The James Lettis Highway currently runs left to right through these fields.

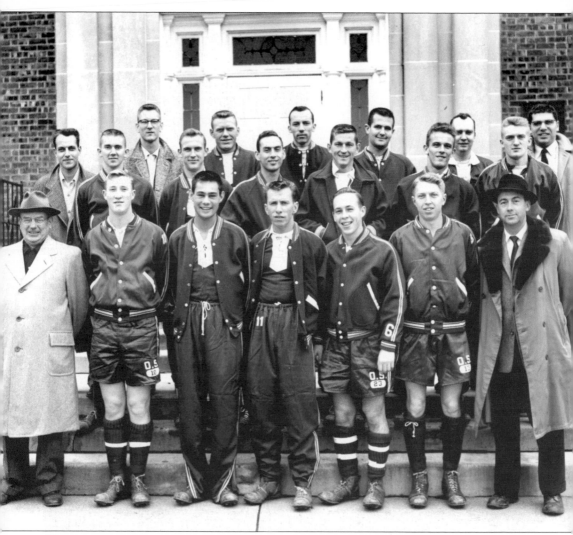

THE FIRST ONEONTA SOCCER TEAM, 1955. Pictured here are, from left to right, the following: (first row) Harry Watkins, Roger Smith, Marcus Silberbusch, Jared Cooper, Bernard Cleveland, Marvin Parshall, and Hurley A. McLean (coach); (second row) Donald Jester, Robert Rosemier, Harold Morris, John Augustine, William Davis, and Donald Bassett; (third row) John Fredette (manager), Joseph Spanfelner (captain), David Brenner, John DuBois, William Moody, Thomas Stallmer, and Gus Felahi. Despite their lack of experience, the Red Dragons finished their first season with two victories and three losses. Oneonta lost their first game to Orange County Community College 5-0 but bounced back to defeat the Albany State Teachers College Junior Varsity 6-3. (Courtesy of David W. Brenner.)

A FUTURE ONEONTA MAYOR. David Brenner was a member of the 1955 team. Although he had played some soccer in high school, many of Brenner's teammates had no prior knowledge of the game. Brenner was a 1959 graduate but returned to his alma mater in 1960 and served in several positions at the college for the next three decades. Brenner also served on the Otsego County Board of Representatives and was mayor of the city of Oneonta from 1985 to 1997. (Courtesy of David W. Brenner.)

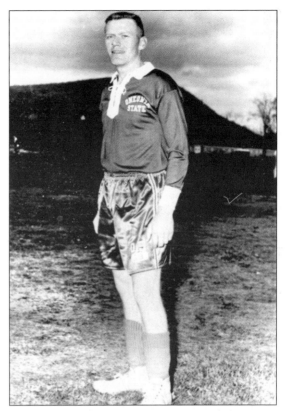

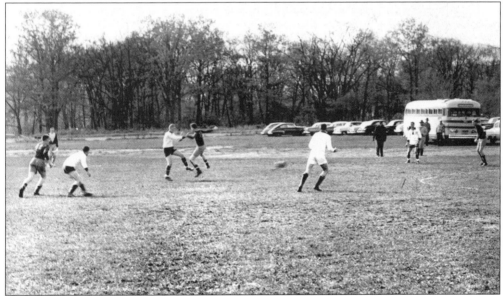

A ROUGH FIELD. Oneonta, in the dark uniforms, is seen playing a home game on Webb Island. Brenner described the field as having some rocks nearly the size of soccer balls. Coach McLean planned an eight-game schedule for 1956, and the Red Dragons began to play against stronger opponents such as LeMoyne, Geneseo, and the West Point Jayvees. (Courtesy of the James M. Milne Library Archives at SUNY-Oneonta.)

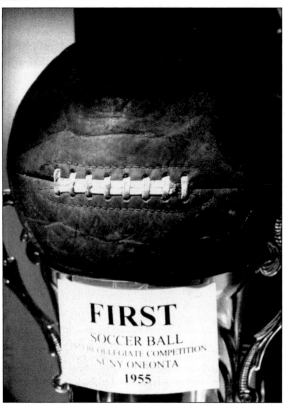

FIRST
SOCCER BALL
INTERCOLLEGIATE COMPETITION
SUNY ONEONTA
1955

LOOKING BACK, MOVING FORWARD. This ball is autographed by the first soccer team at Oneonta State. Captain Joe Spanfelner was later named to the Oneonta State Sports Hall of Fame. Most of the players in the next few years were good athletes but played other sports in addition to soccer. The teams posted respectable records, but the best was yet to come for the soccer program at Oneonta State.

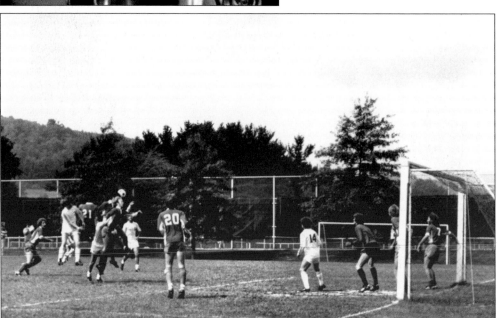

A NEW FIELD. By the early 1960s, the Oneonta State campus was enjoying enormous growth in new enrollment and buildings. A gymnasium building was added to the hillside campus above Old Main, as were these new athletic fields across the road. This soccer field was located where the new Alumni Field House was built in the late 1990s. (Courtesy of Alex Brannan.)

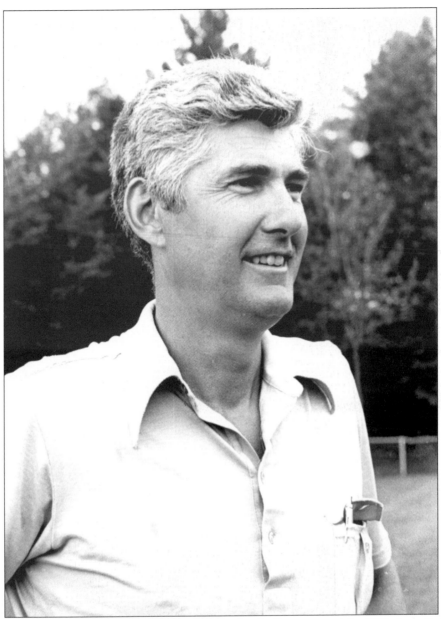

GARTH STAM. Longtime Oneonta State coach Garth Stam arrived in 1961 from Roberts Wesleyan College. At first he coached both soccer and basketball but was able to devote full time to soccer in the late 1960s. Having more time to recruit better players, Stam was able to improve the quality of teams. He was also able to work with the Office of International Education at Oneonta State to give foreign students the opportunity to play soccer and get an education through tuition waivers. It was nicknamed the "Jamaican Dream" in the early 1970s, when Stam recruited two standout players, Altamont McKenzie and Desmond Munroe, from Jamaica. Additional recruiting trips to Europe, Great Britain, and Canada continued to bring up the quality of Oneonta's competitiveness. After the tuition waivers program ended in the late 1970s, Stam continued to recruit excellent players from New York State. Stam retired from coaching in 1989. (Courtesy of the Sports Information Office, SUNY-Oneonta.)

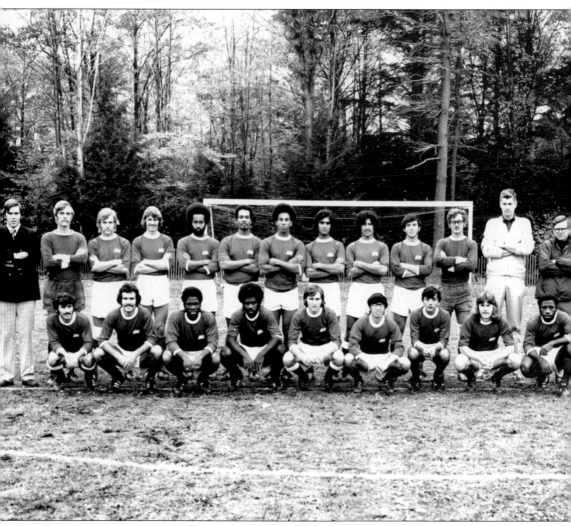

THE 1972 SUPER TEAM. The Red Dragons made it to the NCAA National Championship game that year but lost to Southern Illinois University 1-0. Seen here are, from left to right, the following: (first row) Max Shmuel, John Freitas, Louie Robinson, Bert Bidos, Joe Howarth, Fernando Tiago, Carlos Camacho, David North, and Altamont McKenzie; (second row) Randy Roller (manager), Doug Koch, Frank Gazo, Mike Ballard, Desmond Munroe, Trevor James, Farrukh Quraishi, Ralph Perez, David Garrison, Steve Plisinski, Garth Stam (head coach), and Corky Lynch (assistant coach). (Courtesy of the Sports Information Office, SUNY-Oneonta.)

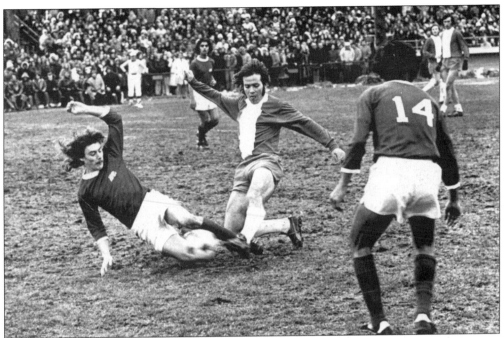

THE RIVALRY BEGINS. Oneonta's 1972 season saw the Red Dragons take on their soccer neighbors from Oyaron Hill, Hartwick College. The two teams had never played before, and they met in a NCAA state division title match in November. The anticipated crowd for such a match moved the game to a neutral site with more seating than what Oneonta State or Hartwick's field could hold. Over 6,000 fans (above) filled Damaschke Field, as Oneonta (in the white shorts), defeated Hartwick 3-0. Some fans chose other seating arrangements (below), and the Delaware and Hudson Railroad yards can be seen in the background. Since 1972, Hartwick and Oneonta have met annually in the regular seasons. (Courtesy of the Paul F. Cooper Jr. Archives at Hartwick College.)

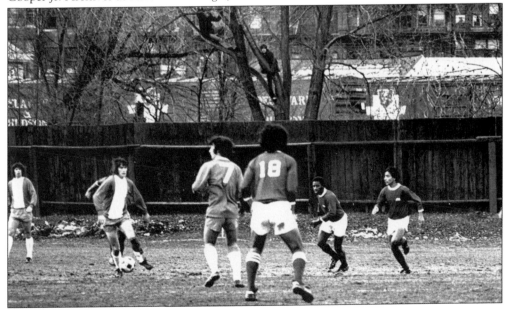

FARRUKH QURAISHI. A native of England, Quraishi achieved the highest honor of any men's soccer player in the history of Oneonta State. As a senior he received the Herman Trophy as the National Soccer Player of the Year in 1974. He was a three-time All-American, All-New York State, and All-Conference player during his college career. He was a first pick in the former North American Soccer League with the Tampa Bay Rowdies. Quraishi continues to be involved in soccer and computer software development. (Courtesy of the Sports Information Office, SUNY-Oneonta.)

KEITH TOZER. During his four-year career with the Red Dragons, Tozer was an All-SUNYAC and All-New York State player. He was the all-time leading scorer for the men's program, with 117 points. For many years, Tozer has been a coach of the Milwaukee Wave of the Major Indoor Soccer League (MISL). Prior to that, Tozer was a member of the 1980 U.S. Olympic team and played with professional teams. (Courtesy of the Sports Information Office, SUNY-Oneonta.)

ALEX BRANNAN. A current resident of Oneonta, Brannan played from 1977 to 1980. He was All-SUNYAC for each of his years, All-State in 1979–1980, and All-American in 1981. Brannan was discovered by coach Garth Stam when his high school team, the Toronto Emeralds, came to Oneonta to play in 1977. After a stint in professional soccer, he returned to Oneonta in the mid-1980s, where he now teaches math and coaches soccer at Oneonta High School. (Courtesy of the Sports Information Office, SUNY-Oneonta.)

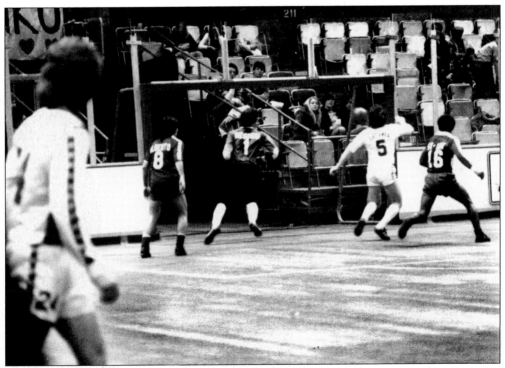

DENVER AVALANCHE'S ALEX BRANNAN. Seen in the foreground, Brannan watches the action in front of the goal, as his MISL team played against the New York Arrows. The Avalanche lost this contest 8-4. (Courtesy of Alex Brannan.)

RALPH PEREZ. With more than a quarter-century of collegiate and professional coaching experience, Perez is now with the L.A. Galaxy of Major League Soccer (MLS). Perez was a starting defender for Oneonta from 1969 to 1973 and part of the squad that played in a losing effort for the 1972 national championship. (Courtesy of the National Soccer Hall of Fame.)

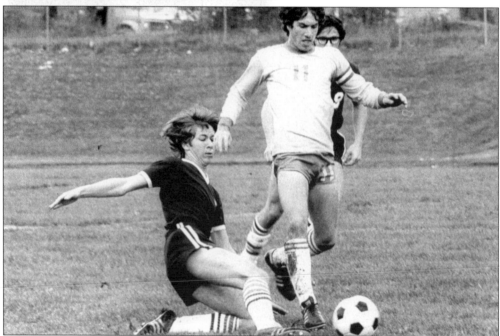

DAVE RANIERI. After graduating Oneonta High School, Ranieri (wearing No. 11) played four years for Oneonta State. After college, Ranieri worked with the National Soccer Hall of Fame to coordinate soccer tournaments in the area. Ranieri now directs the nonprofit Headwaters Soccer Camp for youth and is the assistant coach for the Oneonta State women's soccer team. (Courtesy of Dave Ranieri.)

DON GARBER. A 1979 graduate of Oneonta State, Garber never played soccer here. However, he still has a great deal of interest in Oneonta, as he is the current commissioner of MLS. Garber began his career at NFL Properties as a marketing manager and became the league's director of marketing in 1988, with responsibilities for managing all national NFL corporate sponsorship sales and marketing. He became soccer commissioner in 1999. (Courtesy of the National Soccer Hall of Fame.)

IAIN BYRNE. A recently appointed head coach, Byrne spent six seasons as the program's top assistant. Throughout his career with the Red Dragons, he has been involved in all areas of the program, including recruitment, player development, and overseeing the junior varsity program. Byrne has also directed summer soccer tournaments for the National Soccer Hall of Fame and is the director of the Oneonta Soccer School, a soccer camp for youth. (Courtesy of the Sports Information Office, SUNY-Oneonta.)

LENNY CAMACHO. Another Oneonta native to return to his alma mater, Camacho serves as assistant coach for the Red Dragons. As an Oneonta High School graduate, Camacho was all-time leading scorer. He played four years at Oneonta State. He used his bachelor's degree in art to help create the mascot for the National Soccer Hall of Fame and also helped create the logo for the Calcio Legends soccer club. (Courtesy of the Sports Information Office, SUNY-Oneonta.)

A COMMITMENT TO ATHLETICS. College president Alan Donovan and the previous two presidents have had strong support for all athletic programs at Oneonta State. But in 1999, this was a dream come true, as the Alumni Field House was built near the site of the old soccer field. The 92,000-square-foot building accommodates an indoor track, basketball court, dance studio, and a weight-training and fitness center.

SOCCER NOT FORGOTTEN. In the building of the Alumni Field House, this new soccer field was included in the plans. Construction of the field began in 2000. In the eyes of the current men's and women's soccer coaches, the new indoor facilities, and especially the soccer field, is a boon for recruiting prospective athletes to play at Oneonta State. (Courtesy of the Sports Information Office, SUNY-Oneonta.)

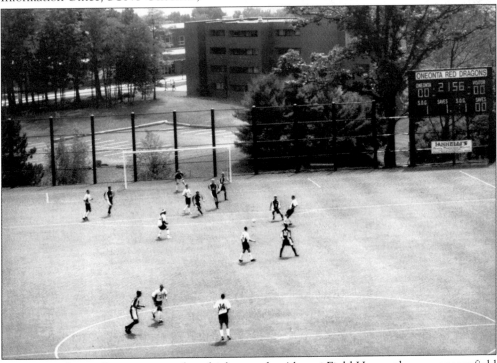

THE FIRST GAME. Seen in a view from high atop the Alumni Field House, the new soccer field opened on September 19, 2001, with the men's soccer team against Siena. Oneonta won in overtime 1-0. During the construction of the field house and new field, Oneonta State's soccer teams mostly played home games at the National Soccer Hall of Fame fields. (Courtesy of the Sports Information Office, SUNY-Oneonta.)

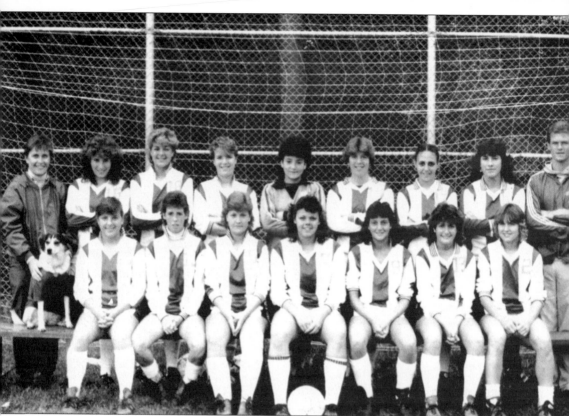

FIRST WOMEN'S SOCCER AT ONEONTA STATE. Until the fall of 1985, there had been no women's varsity soccer team. A soccer club was organized two years earlier and was coached by Prof. Nelson DuBois. This 1985 varsity team finished 5-11, winning their first game ever against Binghamton 2-1. Shown, from left to right, are the following: (first row) Ali (mascot), Julie Boklak, Jenny Moore, Sheryl VanDerKrake, Michelle Guzy, Lisa Aniano, Lisa Casiato, and Deb Budine; (second row) Janet Werdle (assistant coach), Renee Ferluge, Kim Disser, Kim Yerdon, Shari Bogner, Kathy Reilly, Sue Tomasi, Sue Goss, and Alex Brannan (coach). Assistant coach Carol Blazina is missing from the picture. (Courtesy of Public Relations Office, SUNY-Oneonta.)

TRACEY RANIERI. The women's soccer program continued to improve during the next few years. Ranieri became full-time head coach in 1991. The team won their first SUNYAC championship in 1997 and again from 1999 to 2003. Until 2002, those championships meant automatic berths to the NCAA tournaments, but each time the Dragons came home without a national championship. That all changed in 2003.

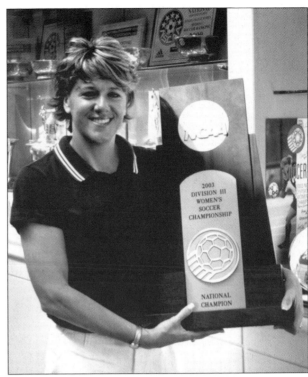

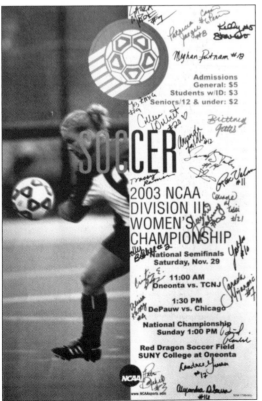

ONEONTA MAKES IT TO THE FINAL FOUR. The Red Dragons won in the regional NCAA championships by penalty kicks to defeat Ithaca in overtime. Oneonta now found itself in the NCAA quarterfinals for the first time ever and had the luxury of playing at home. The school was on its Thanksgiving recess the weekend of this Final Four series.

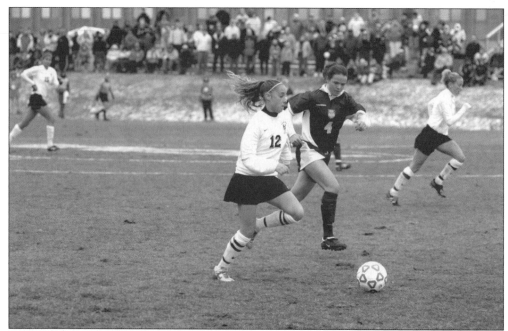

THE GAMES BEGIN. By defeating the College of New Jersey on Saturday 2-1, Oneonta took on the University of Chicago. These two teams were no strangers, as Chicago had eliminated Oneonta in 2002 in an overtime win during the NCAA Central Regional semifinals. Revenge was high on the minds of the Red Dragons, especially in this win for the title of national champion. (Courtesy of Gerry Raymonda Photography.)

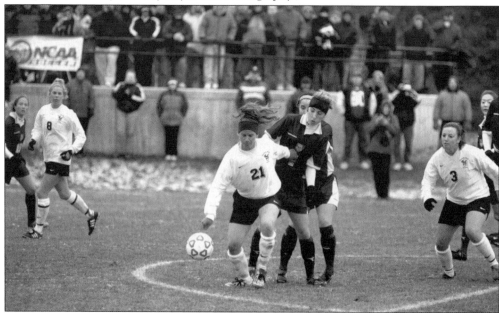

THE HEAT WAS ON FOR THE RED DRAGONS. Fans had to bundle up for the weekend tournament, which had seen some snowfall on Saturday. Fortunately, the sun broke out for Sunday's game. Going into the final minute of play, Oneonta trailed 1-0. (Courtesy of Gerry Raymonda Photography.)

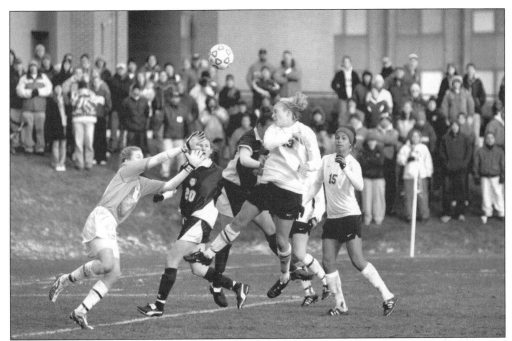

PRESSURE! With the clock continuing to count down, senior Rose Velan had served the ball into the box. With players from both teams disorganized, the Chicago goalkeeper tried to play the ball, but it bounced off her body where it laid loose. Brooke Davis was in the right place at the right time and blasted the loose ball to the back of the net for the game-tying goal with only 29 seconds remaining. (Courtesy of Gerry Raymonda Photography.)

BLINK AND YOU MISSED IT. Overtime didn't last long, as a loose ball found its way to senior Sanada Mujanovic, who crossed the ball in hopes that someone would be charging the back post. Instead, the ball caught the netting just inside the left goalpost near the crossbar for the decisive goal, and Oneonta secured victory 2-1. The Red Dragons react. (Courtesy of Gerry Raymonda Photography.)

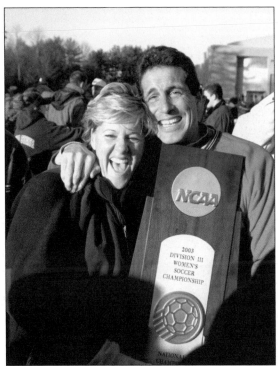

OVERJOYED. Tracey Ranieri and her husband, assistant coach Dave Ranieri, hold the national trophy as the celebration begins for Oneonta, the new NCAA Division III national champions. For the Red Dragons, Brooke Davis was selected as the most outstanding player of the tournament, while Tricia Jaeger, Laura Morcone, and Amanda LaPolla were named to the All-Tournament team. (Courtesy of Gerry Raymonda Photography.)

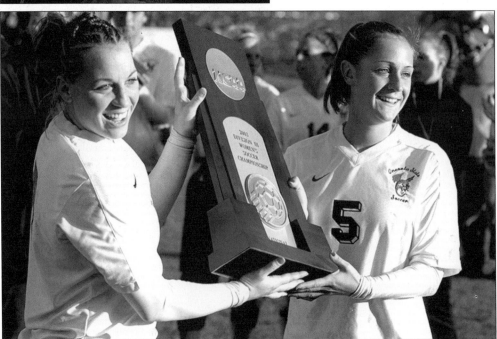

CELEBRATION. Senior co-captains Sanada Mujanovic and Kelly Stevens pose for a picture after being presented with the national championship trophy. Head coach Tracey Ranieri was also selected as the NSCAA national coach of the year for 2003 in Division III Soccer. The season ended with 21 wins against 1 loss and 3 ties. (Courtesy of the Sports Information Office, SUNY-Oneonta.)

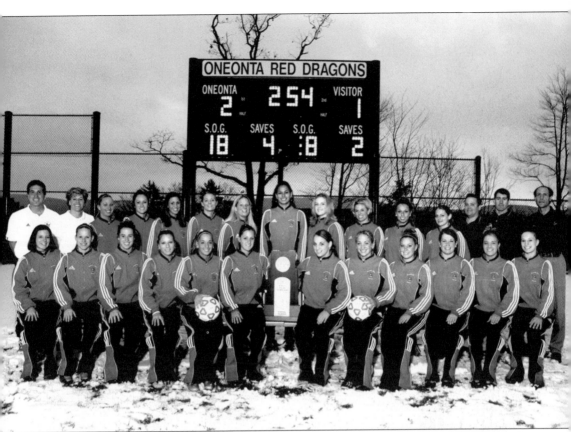

THE 2003 NATIONAL CHAMPIONS. Pictured, from left to right, are the following: (first row) Patricia DiMichele, Corinne Tisei, Candace Grosser, Alissa Karcz, Amanda LaPolla, Kelly Stevens (captain), Sanada Mujanovic (co-captain), Rose Velan, Liz Femia, Meghan Putnam, Brittney Gates, and Holly Bisbee; (second row) Dave Ranieri (assistant coach), Tracey Ranieri (head coach), Cassie Perino, Colleen Wolbert, Alex DeSousa, Brooke Davis, Laura Morcone, Cristina Gaspar, Jami Leibering, Tricia Jaeger, Sarah Tauber, Leslie Small, Andy Spence (assistant athletic trainer), Tom Benoit (head athletic trainer), and Geoff Hassard (sports information director). (Courtesy of the Sports Information Office, SUNY-Oneonta.)

A COMMUNITY CELEBRATION. Days after the victory, a presentation by local dignitaries was given to congratulate the championship team at the Hunt Union Ballroom. Since a majority of the Oneonta State students were away for Thanksgiving recess, the room was crowded with well-wishers. Mayor Kim Muller is at the podium, ready to offer a proclamation from the city at the festive event.

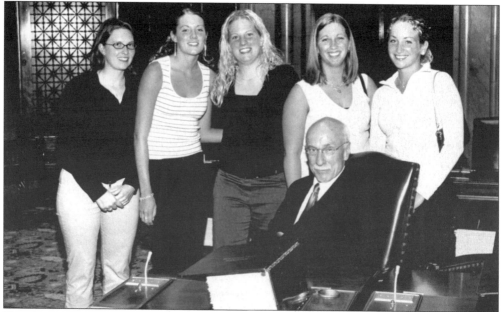

THE CELEBRATION CONTINUED IN ALBANY. Members of the championship team were invited to the capital, to be honored by the New York State Assembly and Senate in June 2004. The legislature adopted a resolution to recognize Oneonta's championship team. Alan Donovan is seated in Sen. James Seward's seat. Seward sent this photograph to Donovan and quipped, "Since you appear to enjoy sitting in that senate chair so much, should I be worried?" (Courtesy of Public Relations Office, SUNY-Oneonta.)

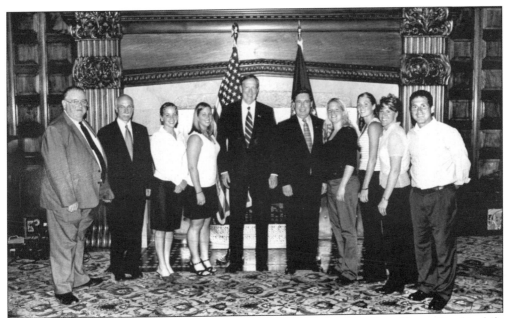

MEETING THE GOVERNOR. Members of the championship team met Gov. George Pataki while visiting Albany. Pictured, from left to right, are the following: assemblyman Bill Magee, Oneonta State president Alan Donovan, Rose Velan, Cassie Perino, Governor Pataki, Sen. James Seward, Laura Morcone, Brooke Davis, Tracey Ranieri, and Dave Ranieri. (Courtesy of Public Relations Office, SUNY-Oneonta.)

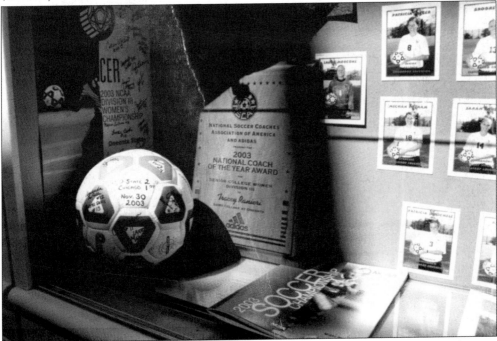

A FULL TROPHY CASE. Memories of the 2003 women's soccer season will live on in history. Seen here in a display case at Alumni Field House is the ball used in the championship game, the plaque given to Tracey Ranieri for her outstanding coaching, and other memorabilia.

COLLEGE AT ONEONTA
ATHLETIC HALL OF FAME

THE BEST OF ONEONTA STATE. Soccer players and coaches have plaques in this display through 2003. The honorees are Alex Brannan, Laddie Adam Decker, Ronan Downs, Bryan Hassett, Joe Howarth, Altamont McKenzie, Judson Magrin, Desmond Munroe, Farrukh Quraishi, Joseph Spanfelner, Garth Stam, and Keith Tozer. Induction ceremonies are traditionally held as part of homecoming and family weekend at the college.

Three
HARTWICK COLLEGE SOCCER

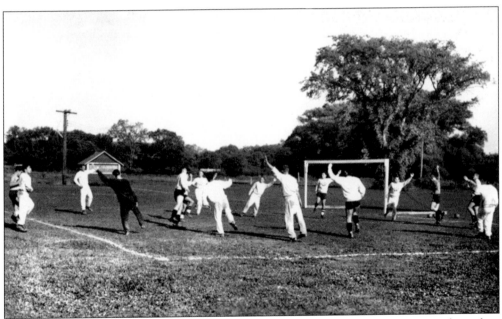

HUMBLE BEGINNINGS AT HARTWICK COLLEGE. In the fall of 1956, the Warriors formed its first intercollegiate soccer team. They started the season with little experience, but under coach Hal Grieg, they put together a 2-3 record. They won their first game against LeMoyne College. (Courtesy of the Paul F. Cooper Jr. Archives at Hartwick College.)

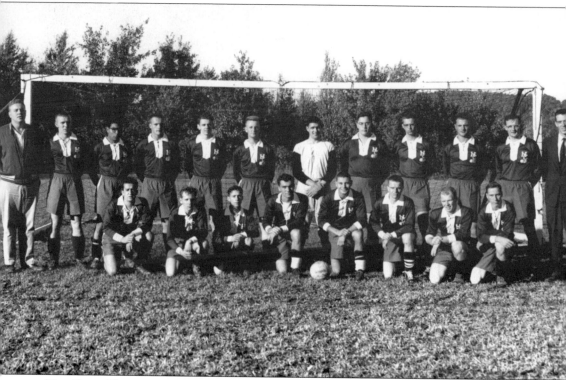

THE FIRST HARTWICK COLLEGE TEAM, 1956. Pictured, from left to right, are the following: (first row) K. Altenhofen, D. Zeh, W. Gold, R. Baehm, J. Ross, R. Keegan, J. Lockwood, and W. McFall; (second row) C. Girvin (manager), G. Moller, A. Rosario, C. Epplemann, T. Edmonds, C. McCabe, G. Smith, A. Mello, R. Mjaatvadt, R. Papa, F. Ortgies, and H. Grieg (coach). (Courtesy of the Paul F. Cooper Jr. Archives at Hartwick College.)

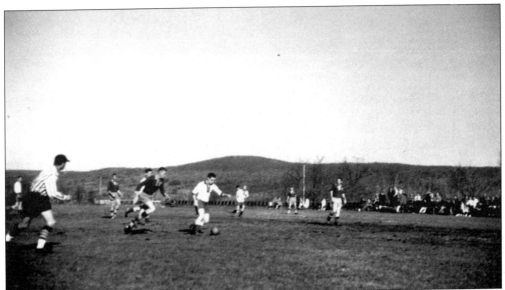

STEADY IMPROVEMENT. Coach Grieg remained at Hartwick for three more seasons, culminating his stay with an 8-1 mark in 1959. Grieg also owns the distinction of coaching the first of Hartwick's 25 All-American players. Larry Serfis earned All-American honors following the 1959 campaign. David Haase followed Grieg as head coach and produced a 55-15-3 record. Haase directed the school's first NCAA playoff berth in 1962 and led the team to the tournament again in 1964. (Courtesy of the Paul F. Cooper Jr. Archives at Hartwick College.)

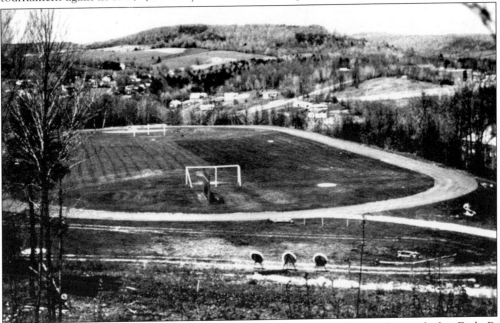

ELMORE FIELD. After World War II, this field was dedicated in 1948 and named after Earle P. Elmore, a trustee of the college. Elmore also had a thriving business in Oneonta, the Elmore Milling Company. This field was originally used for football and baseball, among other sports. The football program was dropped c. 1950, so soccer games were played here from the beginning. (Courtesy of the Paul F. Cooper Jr. Archives at Hartwick College.)

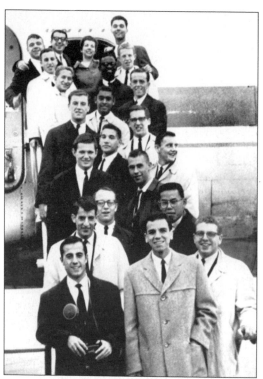

GETTING SOME RESPECT. The 1963 Hartwick College Warriors team poses at the Broome County Airport before their flight to South Bend, Indiana, to play Notre Dame. This game was the biggest event in the young soccer program's history, and Hartwick won 4-2. Seen behind the man with the camera (front), is Nick Papadakis. His career number of goals scored for Hartwick continues to stand as a school record at 76. (Courtesy of the Paul F. Cooper Jr. Archives at Hartwick College.)

THE TEAM AT DR. BINDER'S HOME. College president Frederick Binder greets the 1964 soccer team. Binder was a strong influence in building the college's athletic program. As Hartwick's soccer teams improved, Binder hired Jim Konstanty as athletic director. The team, under Konstanty and new coach Al Miller, traveled to Europe in 1968 for a 17-day trip with 14 games to play and much to learn from powerful young teams. Hartwick was chosen for the tour because of the team's steady improvement from 1963. (Courtesy of the Paul F. Cooper Jr. Archives at Hartwick College.)

The Success Continued.
In 1967, Al Miller (center) won
his first 11 games as head coach.
The team eventually split a pair of
Atlantic Coast Tournament games
in the postseason. During Miller's
six-year stay, Hartwick qualified
for postseason play every season
and reached the NCAA Division I
Final Four in 1970. His teams
posted an impressive 7-3 mark in
NCAA playoff contests. (Courtesy
of the Paul F. Cooper Jr. Archives
at Hartwick College.)

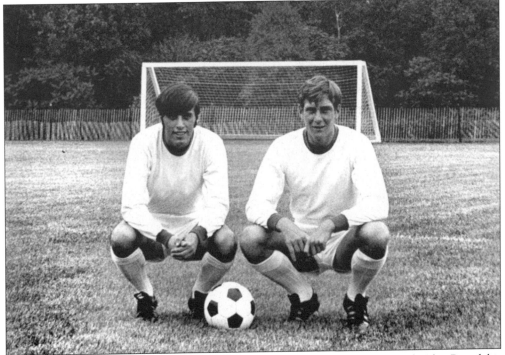

Co-Captains, 1970. Coach Al Miller had an incredible arsenal of power with Alec Papadakis
(left) and Timo Liekoski on the squad. Just like his brother Nick, Alec Papadakis was a record
setter for Hartwick. Alec still holds the all-time season point total with 56 and is second in
career points and goals, behind brother Nick. Timo Liekoski played from 1968 to 1970 and was
an All-American player. Liekoski succeeded Al Miller as coach in 1971. (Courtesy of the
Sports Information Office at Hartwick College.)

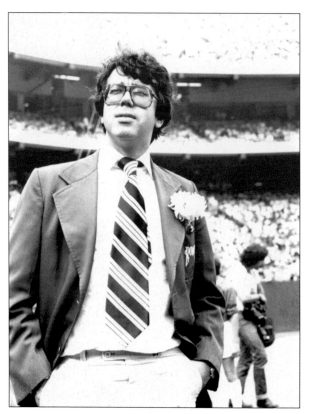

FRANCISCO MARCOS. Although he played from 1965 to 1967, Marcos had a big influence on soccer in Greater Oneonta. After graduation in 1968, Marcos was a graduate assistant at Oneonta State and was helpful in gaining some recruits for coach Garth Stam. Marcos is also credited with forming the early stages of the Oneonta Youth Soccer Program. Among his many activities after Oneonta, Marcos was the founder and current commissioner of the United Soccer Leagues, America's largest collection of professional and amateur soccer leagues. (Courtesy of the Sports Information Office at Hartwick College.)

BINDER PHYSICAL EDUCATION CENTER. Many buildings were erected on the Hartwick College campus during Frederick Binder's tenure (1959–1969). As proof of his commitment to athletics, this building was completed in 1968, replacing the former field house, which was a navy surplus building in World War II. (Courtesy of the Paul F. Cooper Jr. Archives at Hartwick College.)

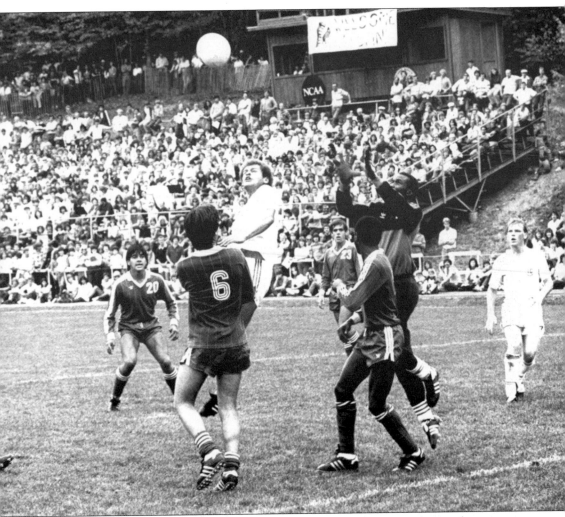

WHAT A CROWD. With the soccer program continuing to improve, and annual returns to NCAA playoffs, the number of fans attending the games at Elmore Field surged. It was not only the Hartwick students at these games. As the Oneonta Youth Soccer Program grew in popularity, youth and their families became frequent attendants at the games. In 1972, when Hartwick faced Oneonta State in a New York State NCAA divisional final, neither this field nor the one at Oneonta State was able to hold the expected capacity crowd. (Courtesy of the Paul F. Cooper Jr. Archives at Hartwick College.)

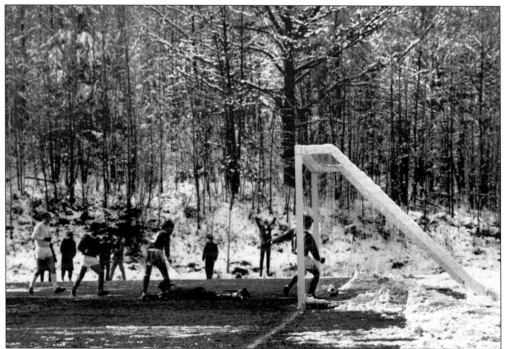

ANOTHER LONG, GREAT SEASON. Taken between 1968 and 1976, this photograph could be from any one of those extended seasons, in November. Between the years of coaches Al Miller and Timo Liekoski, the snow was a common sight during the playoffs on Oyaron Hill. (Courtesy of the Paul F. Cooper Jr. Archives at Hartwick College.)

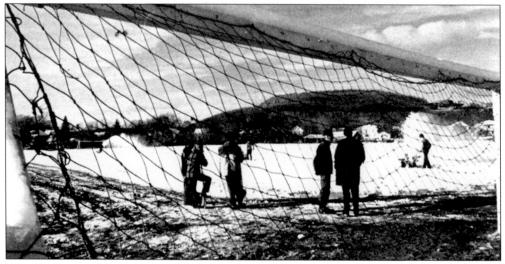

ALL HANDS ON DECK. There were a few instances during the early to mid-1970s when the snowfall was heavy the night before a NCAA playoff game took place. The fields were not sturdy enough for truck plows, so Hartwick called on fans and volunteers to bring their snow shovels to help remove snow. This also became the method to remove snow for playoff games at Damaschke Field when play was impossible at Elmore Field. There were never cancelled games from snow thanks to snow-removal efforts by loyal fans. (Courtesy of the Paul F. Cooper Jr. Archives at Hartwick College.)

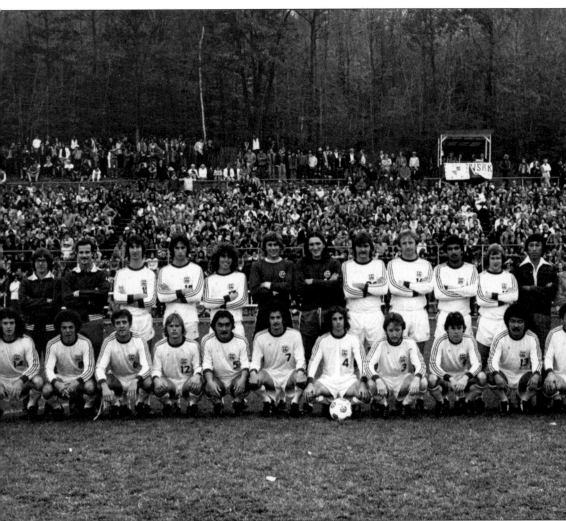

THE 1977 CHAMPIONSHIP TEAM. Coach Jim Lennox arrived for the 1976 season and quickly took his first team to 16-1-1 and finished third in the NCAA Tournament. In 1977, the Warriors posted an undefeated regular season. Pictured, from left to right, are the following: (first row) Joe Ryan, Tom Maresca, Jeff Tipping, Gary Vogel, Khyien Ivanchukov, Art Napolitano, Billy Gazonas, Duncan Macdonald, Steve Long, Zeren Ombadykow, and Peco Bosevski; (second row) Toby Cook (manager), Alden Shattuck (assistant coach), Scott Brayton, David Moore, Robert Cuddy, Mike Blundell, Aly Anderson, Charlie Kadupski, Phil Wallace, Rudy Pena, John Young, Randy Escobar, and Jim Lennox (head coach). (Courtesy of the Paul F. Cooper Jr. Archives at Hartwick College.)

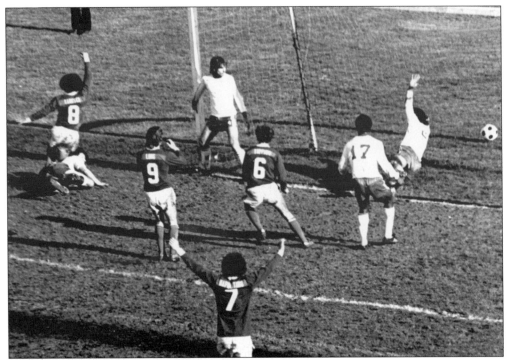

THE PATHWAY TO THE CHAMPIONSHIP. In the 1977 playoffs, the Warriors defeated St. Francis, Cornell, and Philadelphia Textile to reach the Final Four held at Berkeley, California. There, Hartwick defeated Brown 4-1. The national championship game was set, pitting Hartwick against two-time defending champions, the University of San Francisco. (Courtesy of the Paul F. Cooper Jr. Archives at Hartwick College.)

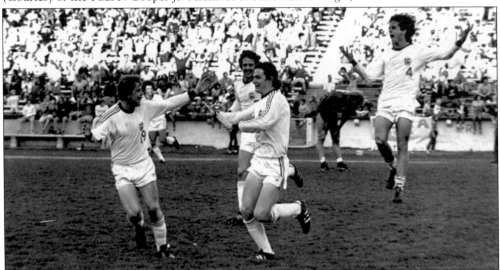

SWEET VICTORY DRAWS CLOSER. What turned out to be the winning goal in the first half of the game put Hartwick ahead, 2-0. Celebrating are Steve Long (center), John Young (19), Billy Gazonas (4), and Art Napolitano. USF put on a last half flurry of shots, but goalkeeper Aly Anderson turned them all away to preserve the win 2-1. (Courtesy of the Paul F. Cooper Jr. Archives at Hartwick College.)

50

THE CELEBRATION BEGINS. Billy Gazonas holds aloft the 1977 NCAA championship trophy following the win on Sunday, December 4. Gazonas is on the shoulder of teammate Duncan Macdonald, who recently returned to Oneonta and is now the Hartwick College director of alumni relations. (Courtesy of the Paul F. Cooper Jr. Archives at Hartwick College.)

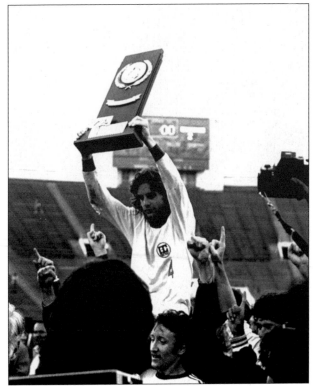

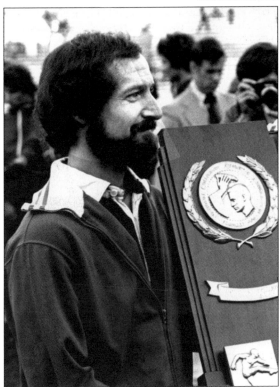

PROUD OF HIS TEAM. Coach Jim Lennox holds the championship trophy at ceremonies following the game. Lennox had much to be proud of, as Hartwick's John Young was named the Final Four's offensive MVP. Jeff Tipping was named the tournament's defensive MVP. It was time to bring the celebration back to the city of Oneonta. (Courtesy of the Paul F. Cooper Jr. Archives at Hartwick College.)

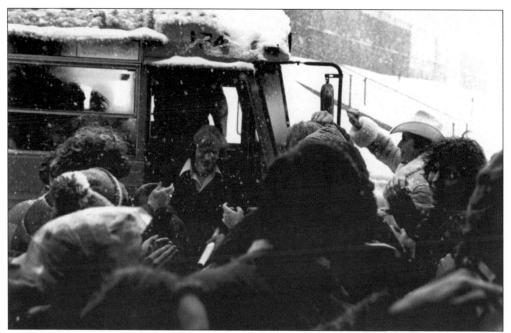

GREETED BY A SNOWSTORM. The Warriors flew back from California to Syracuse and took a charter bus to Oneonta. That bus got them as far as the foot of Oyaron Hill, because the roads were too slippery for the charter bus to get up the hill to the Binder Physical Education Center. Fortunately, an Oneonta school bus with chains was nearby and helped them to complete the trip. The players were warmly greeted upon their arrival. (Courtesy of the Paul F. Cooper Jr. Archives at Hartwick College.)

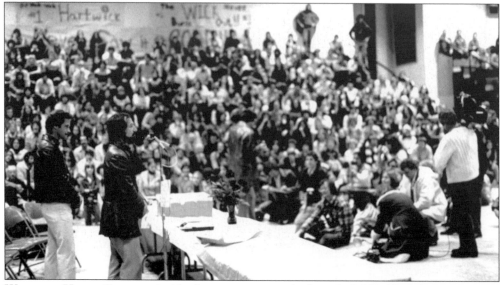

WELCOME HOME, CHAMPS. Inside the center, a crowd of nearly 2,000 filled the gymnasium. Coach Jim Lennox addressed the fans that helped make the season such a success. Since Sunday night, the Hartwick College campus and entire community had been abuzz with activity. Students got in their cars, drove around the Oneonta streets, and honked their horns with shouts of "We're No. 1!" (Courtesy of the Paul F. Cooper Jr. Archives at Hartwick College.)

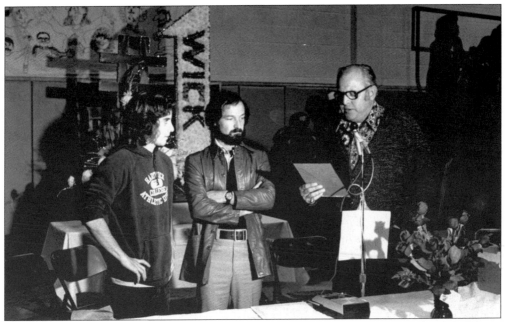

A PROCLAMATION. Mayor James Lettis (right) declared Monday as We're Number One Day in Oneonta. Billy Gazonas and Jim Lennox listened during the ceremonies in the gym. This Hartwick championship was one of the many events that got local citizens more interested in answering the repeated questions floating around the community as to where a National Soccer Hall of Fame was located, and why not in Oneonta? (Courtesy of the Paul F. Cooper Jr. Archives at Hartwick College.)

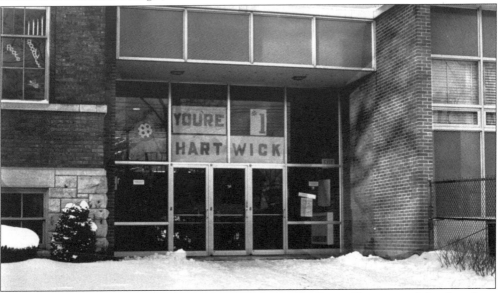

COMMUNITY PRIDE IN THEIR CHAMPIONS. Nearby Center Street Elementary School got busy decorating the entrance to the education center. Youth soccer in Oneonta had already been doing well since Francisco Marcos invited youth to play the game in Neahwa Park in 1968. A NCAA championship in their hometown only made the youth involvement even stronger. (Courtesy of the Paul F. Cooper, Jr. Archives at Hartwick College.)

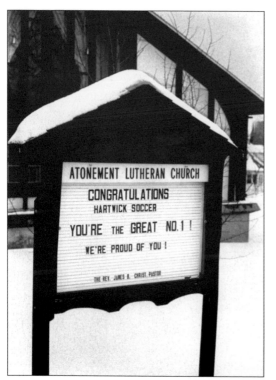

EVEN THE ALMIGHTY TOOK SOME TIME OFF TO CELEBRATE. The enthusiasm toward soccer did not wear off anytime soon. The nickname Soccertown, USA, was being used more and more by local residents. New soccer tournaments in the community were just getting started about the time of this championship season and have been around ever since. (Courtesy of the Paul F. Cooper Jr. Archives at Hartwick College.)

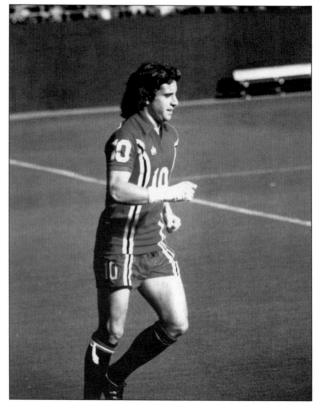

BILLY GAZONAS. Life after Hartwick went well for Gazonas, as he played for several seasons with the Kansas City Comets and then became assistant coach for this Major Indoor Soccer League team. Gazonas wore No. 4 at Hartwick. His and Glenn Myernick's No. 2 are the only numbers that have been retired at Hartwick. (Courtesy of the Paul F. Cooper Jr. Archives at Hartwick College.)

GLENN MYERNICK. A 1977 Hartwick graduate, Myernick is seen here in a Dallas Tornado uniform, where he played from 1977 to 1979. He became head coach of MLS' Colorado Rapids from 1997 to 2000. Myernick then became the assistant coach for the U.S. National Team at the 2002 World Cup. Myernick is the current head coach of the U.S. Olympic team. (Courtesy of the Paul F. Cooper Jr. Archives at Hartwick College.)

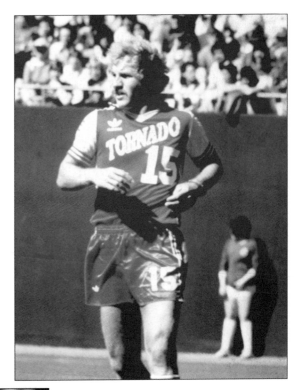

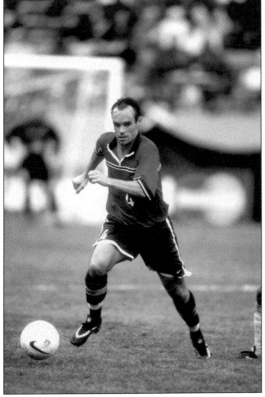

MIKE BURNS. A midfielder in the late 1980s and early 1990s, Burns became a member of the U.S. National Team, playing 75 international matches from 1992 to 1998. He was an original member of the New England Revolution of MLS but was traded to the San Jose Earthquakes in 2000, where he currently plays. (Courtesy of the National Soccer Hall of Fame.)

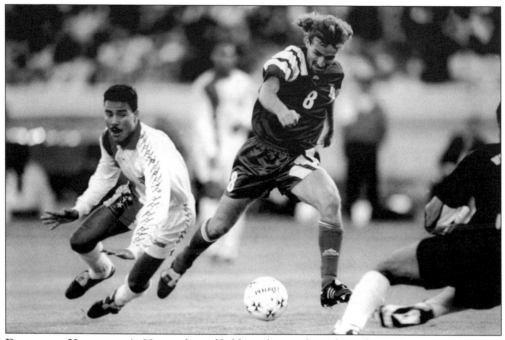

DOMINICK KINNEAR. A Hartwick midfielder who graduated to the U.S. National Team, Kinnear played 56 international games and scored nine goals from 1990 to 1994. He continued his major-league career as an assistant coach and won a championship ring with the 2001 San Jose Earthquakes. (Courtesy of the National Soccer Hall of Fame.)

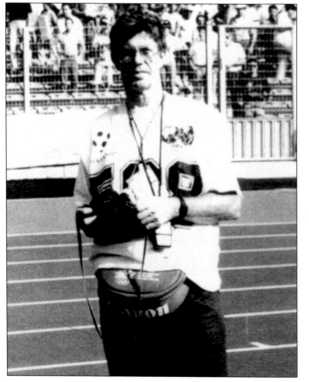

ED CLOUGH. As a former Hartwick College sports information director and noted photographer, Clough has also been seen along the sidelines capturing the action of World Cup, Olympic, North American Soccer League, and MLS games. His photographs have been used in numerous soccer publications. Clough donated many of his photographs to the National Soccer Hall of Fame and Hartwick College, so although this book gives proper credits to these institutions for use of photographs, many were taken by Ed Clough. (Courtesy of the National Soccer Hall of Fame.)

JIM LENNOX. From 1976 to 2002, head coach Jim Lennox led the men's soccer team to a 318-163-43 record. At the time of his retirement, Lennox was ranked the 14th all-time among the most winning NCAA Division I coaches. Hartwick reached the NCAA Tournament 13 times during the Lennox era, and he guided the program to the semifinal round of the playoffs five times. Hartwick also reached the Final Four in 1980, 1984, and 1985. Fourteen Hartwick players have garnered a total of 19 All-American honors during Lennox's tenure. (Courtesy of the Sports Information Office at Hartwick College.)

IAN MCINTYRE. Hartwick's current head coach, Ian McIntyre is no stranger to Elmore Field, as he earned All-American honors as a member of the men's soccer team in 1995. He returned to Hartwick after four years as head coach at Oneonta State, where he posted a 36-28-7 record. McIntyre started his collegiate coaching career at Fairfield University. (Courtesy of the Sports Information Office at Hartwick College.)

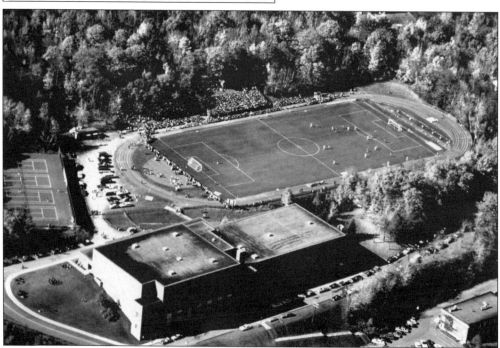

IMPROVED SINCE 1956. In addition to Elmore Field, the team practices on nearby Table Rock Fields or All-Weather Field. The latter is artificial turf, which helps prepare the team for road contests on artificial surfaces. The Elting Fitness Center is used for training inside the Binder Physical Education Center, a luxury the 1956 soccer team did not have. (Courtesy of the Paul F. Cooper Jr. Archives at Hartwick College.)

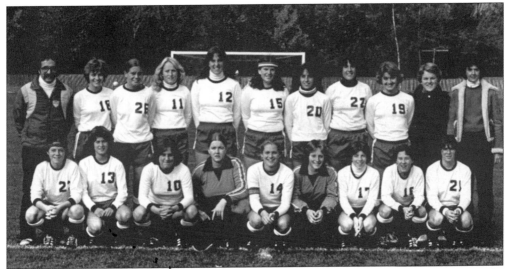

HARTWICK WOMEN'S VARSITY SOCCER BEGAN IN 1980. Pictured, from left to right, are the following: (first row) Holley Mitchell, Mindy Grinold, Lisa Sposato, Sue Smith, Rachel Duell (captain), Lisa Smith, Pat Flint, Kitty Hughes, and Kathy Barnes; (second row) David Robinson (coach), Linda Sage, Kate Warren, Ginger Swingle, Zebby Whiting, Verone Flood, Jo-Ann Garrison, Kim Mackay, Patti Sellevold, Ann Jealous, and Carol Lewis. The 1980 team (below) was highly successful, tallying an 8-1-1 record. In its history through 2003, the Hartwick Women's Soccer program has proven to be a strong winner, with a 215-170-40 record. (Courtesy of the Paul F. Cooper Jr. Archives at Hartwick College.)

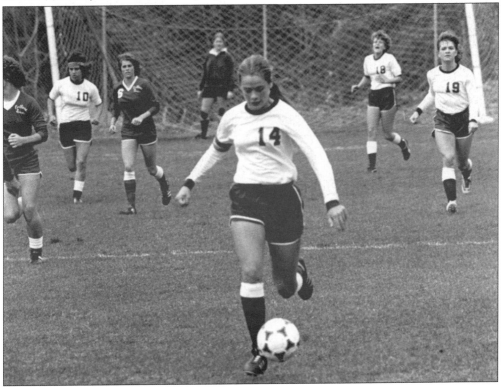

HARTWICK'S BEST. Men's and women's soccer players and coaches have plaques near the gymnasium of the Binder Physical Education Center. In alphabetical order through 2003, they are Aly Anderson, Eddie Austin, Megan Becker, John Bluem, Gregory Moss Brown, Michael Burns, Gina Burrows, David D'Errico, Iain Fraser, Billy Gazonas, Mike Harrison, Eddie Hawkins, Matthew Kmosko, Jim Lennox, Timo Liekoski, David Long, Francisco Marcos, Tony Martelli, Ian McIntyre, Mark Mettrick, Al Miller, Glenn Myernick, Karen Berkel O'Brien, Alec Papadakis, Nick Papadakis, Walter Piepke, Kate Stoehr, Dough Wark, and Cathy Wood.

Four

ONEONTA
HIGH SCHOOL SOCCER

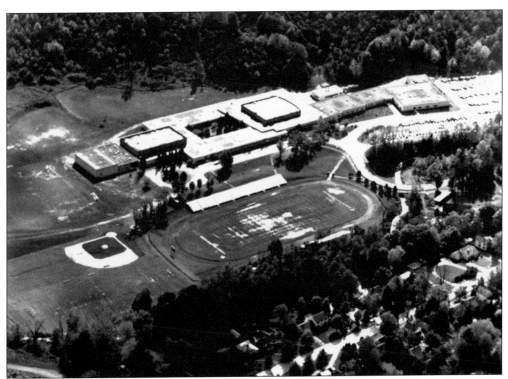

NEW IN 1964. Oneonta High School (left) replaced an old structure on Academy Street. The middle school (right) was opened in the late 1970s. These grounds provided playing space on the school grounds. At the old school, outdoor sports teams played in Neahwa Park or Webb Island. It was not until 1968 that varsity soccer was first played at Oneonta High.

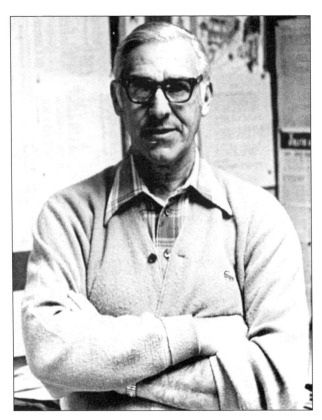

TONY DRAGO. Oneonta High's athletic department chairman from the 1960s through 1980s, Drago said there had been interest in soccer among students, as they were already playing intramurals. In 1968, Oneonta joined a league of schools in Delaware County to have a soccer team. Charles Maben, who had been coordinating soccer intramurals, was appointed the first coach. (Courtesy of the Oneonta City School District.)

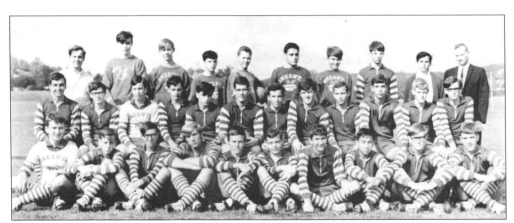

ONEONTA HIGH'S FIRST TEAM. Pictured, from left to right, are the following: (first row) T. Henrich, J. Stanley, J. Wilson, J. Franzese, M. Solano, T. Parker, A. Beach, S. Eguchi, E. Winans, and L. Shultis; (second row) R. Kalweit, J. House, T. Brienza, L. Close, K. Clarkson, J. Austin, D. Parker, J. Sheesley, G. Daley, C. Hale, E. Rowley, and D. Lynch; (third row) R. House (manager), K. Leydon, P. Squaires, M. Oliver, R. Jordan, D. Wiedeman, F. Chase, J. Hawley, D. Clark, and Charles Maben (coach). (Courtesy of the Oneonta City School District.)

FIRST GAME. Kurt Clarkson races to keep the ball from a Davenport opponent in the season opener, which the Yellowjackets won 3-0. The 1968 campaign was successful, ending 6-3-1. Oneonta played much smaller schools, such as South Kortright, Downsville, and Stamford in what was called the Delaware Northern League. (Courtesy of the Oneonta City School District.)

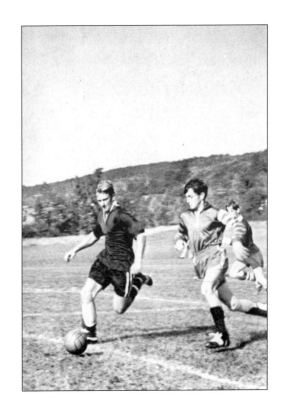

GREAT SAVE. Terry Brienza stops a goal against Schenevus, a game Oneonta High won in overtime 4-3. The first soccer field was located approximately on the site of today's indoor swimming pool. In the next few years, Oneonta's teams showed steady improvement. (Courtesy of the Oneonta City School District.)

HEAVY TRAFFIC. An Oneonta player gets trapped between two Davenport players in a game during the 1970 season. The Delaware Northern League no longer wanted Oneonta in the league due to the Yellowjackets' size and skill. All other Oneonta sports were played in the Iroquois League; however, none of the other schools had soccer teams. For a few years after 1970, Oneonta played other schools on an independent basis. (Courtesy of the Oneonta City School District.)

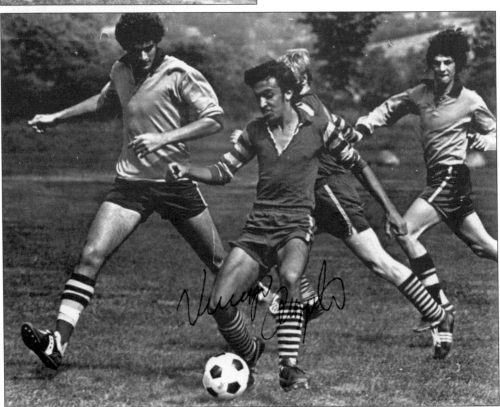

IN A NEW LEAGUE. Schools in the Southern Tier Athletic Conference (STAC) had soccer teams, and Oneonta entered play in that league in 1973. New opponents were larger schools in the Greater Binghamton and Ithaca areas. Here, Vinnie Avanzato controls the ball against some defenders. (Courtesy of the Oneonta City School District.)

NEW LEAGUE, NEW COACH. Tom Duffy became head coach for the Yellowjackets in the 1973 season. The first season had Oneonta as STAC division champions, but they were one goal short of winning the New York State Section IV crown. Duffy led many strong campaigns during his years until the mid-1980s. The structure of state playoffs was different at that time. Duffy is a member of the Section IV Coaches Hall of Fame. Duffy also coached for a short time at Oneonta State. (Courtesy of the Oneonta City School District.)

FROM GOALIE TO ATHLETIC DIRECTOR. Joe Hughes played for Tom Duffy as goalkeeper in those early years in the STAC. Hughes said his interest in soccer stemmed from the Oneonta Youth Soccer League, which started in the late 1960s. Hughes also played basketball but specialized in baseball. Hughes returned to Oneonta High to teach in the 1980s and coach baseball. He became athletic director in 1999.

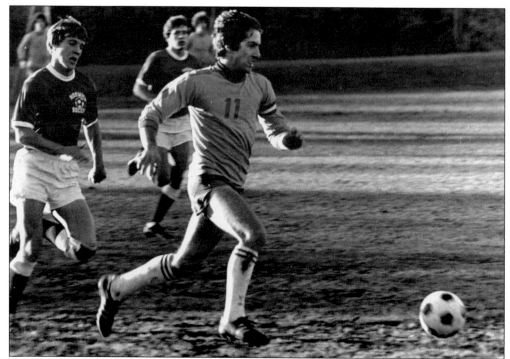

DAVE RANIERI AT OHS. After Tracey and Dave Ranieri won the Oneonta State Women's Championship in 2003, Dave received a congratulatory call from Tom Duffy. Ranieri said that part of that victory was Duffy's, as his former coach made a lasting impression on him while playing at Oneonta High in the late 1970s, and later in coaching. (Courtesy of Dave Ranieri.)

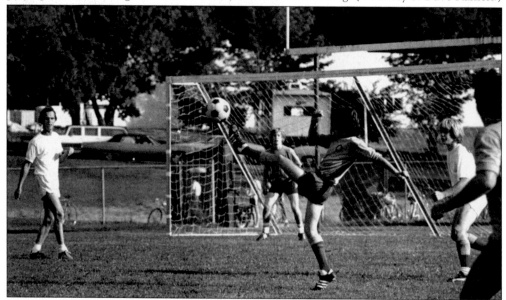

THE OLD OHS STADIUM. After the indoor pool was built in the late 1970s, the soccer team shared the football field for a few years. Eventually, the school's upper field was constructed for soccer practice and occasional contests. This game was played on Mayor's Cup Weekend in 1976. (Courtesy of the Daily Star.)

LLOYD BAKER FIELD. The Oneonta High School stadium underwent massive renovations in the late 1990s, as lights, a new track, press box, concession building, and bleachers were added. Only on special occasions do the boys and girls soccer teams play here, as they now prefer the fields at the National Soccer Hall of Fame.

ALEX BRANNAN. Only the third boys' soccer coach in Oneonta High history, Brannan became varsity head coach in 1986. Brannan was an Oneonta State graduate and a standout soccer player for the Red Dragons. He also played professionally for a few years. He now teaches math at Oneonta High School. In the tradition of Tom Duffy, Brannan has kept the winning seasons alive and well and has had one team that won the overall New York State championship, so far.

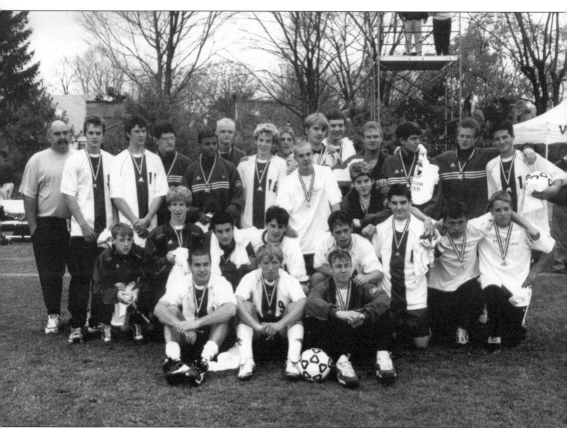

THE 1999 CLASS B NEW YORK STATE CHAMPIONS. Since the 1970s, the playoff structures have changed. This team claimed the state title in 1999. Pictured, from left to right, are the following: (first row) Ryan Jones, Mike Connolly, and Brian Murphy; (second row) Peter Goebel, Dan Colone, Jim Puritz, A. J. Hecox, Dave Sweet, Matt Shea, Mark Maynard, and Mark Demer; (third row) Tim Smith (assistant coach), Jeff Gallusser, Mike Austin, Mike Nader, Fray Haile, Troy Biehlert, Andrew Lunn, Josh Gallusser, Aaron Dallara, Carrick Detweiler, Mike Golden, Ryan Martindale, Alex Brannan (coach), Jamal Rab, Josh Bailey, and Andy Smith. (Courtesy of the Daily Star.)

BIG GOAL. Jeff Galluser and Andy Smith celebrate after Gallusser scored the first goal on the team's way to defeating Section XI's Hauppague 4-0. Other goals came from Aaron Dallara, Mike Austin, and Matt Shea. The game was played at Vassar College in Poughkeepsie. The Yellowjackets completed the year as the only undefeated boys' soccer team in New York State, ending the season 23-0. (Courtesy of the Daily Star.)

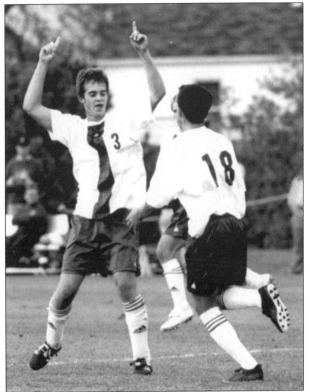

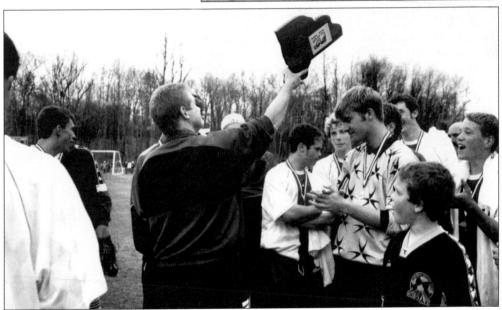

ONE FOR THE TROPHY CASE. Coach Alex Brannan holds the championship plaque as goalie Carrick Detweiler and his teammates cheer after winning the title. Oneonta had defeated Pittsford-Sutherland and Cornwall on the way to this triumph. Hauppauge had defeated Christian Brothers Academy of Syracuse, the state's only other undefeated team at the time, to face Oneonta. (Courtesy of the Daily Star.)

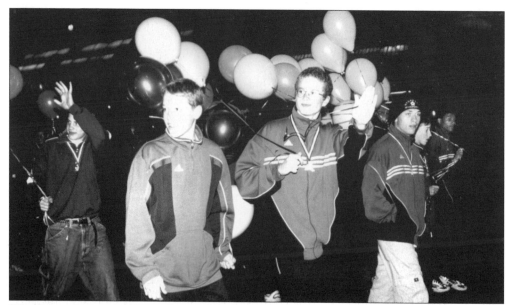

WEAR THE GOLD AND BLUE. Oneonta citizens were asked to wear the school colors to a parade and reception to honor their champions a few evenings after the victory. Seen above are, from left to right, Josh Gallusser, Mark Demer, Josh Bailey, Mark Maynard, Peter Goebel, and Fray Haile. The boys are marching up Main Street toward city hall. Below, sisters Mary and Mabel Hodges shout their support for the Oneonta boys. Oneonta High School principal Scott Rabeler praised them as scholar athletes, as each member maintained a 90 or above average. Mayor Kim Muller acknowledged the players' parents and their work to get the boys where they are. (Courtesy of the Daily Star.)

SOAKING IT IN. The Oneonta High School boys' champion team stands on the steps of city hall, listening to praise for their achievements. They are holding a portion of the 164 balloons for the ceremonies. That number represented the number of goals scored in the season, a record for the school. From this squad, Jeff Gallusser went on to play for Oneonta State, and Troy Biehlert played for Hartwick College. (Courtesy of the Daily Star.)

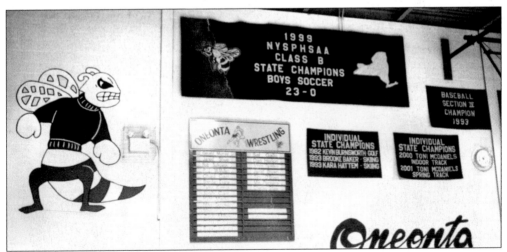

FOR ALL TO ADMIRE. The 1999 soccer championship banner in the Drago Gymnasium is just one of many school sports milestones on display at the high school and around the community. A trophy case is on display outside the gymnasium. As you enter the city, a sign welcomes visitors by displaying a few of the more recent sports accomplishments at Oneonta High.

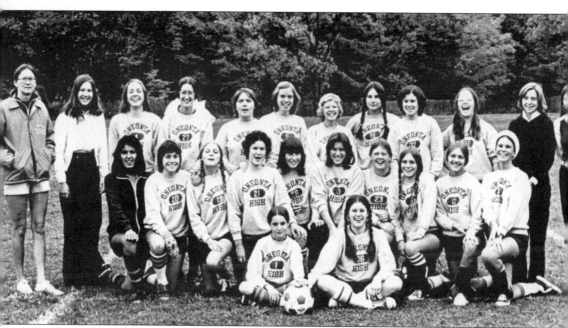

THE FIRST GIRLS' SOCCER TEAM, 1974. After years of playing soccer at an intramural level, this was the school's first varsity team. Pictured, from left to right, are the following: (first row) Anne Marie Fox and Janice Thomas; (second row) Denise Olivencia, Jackie Higgins, Mary Ferris, Mel Renner, Gael Hickey, Debbie Pierce, Mary Ann Belmont, Julie Van Dusen, Debbie Decker, and Karen Laskaris; (third row) Helen Sandford (coach), Anne Lyall, Lynnae Ponder, Julie Germond, Kathy Kelly, Jeanne Broe, Ellen Lyons, Lisa Reynolds, Jacquie Greeley, Nancy Lynch, Pam Harney, and Carla Loucks. Kathy Christ is missing from the photograph. (Courtesy of the Oneonta School District.)

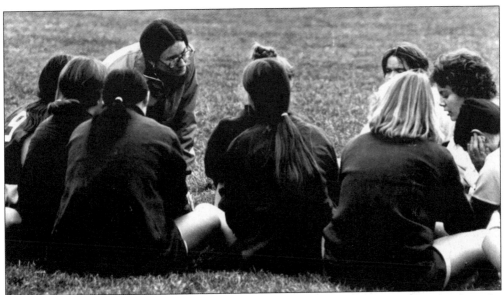

STRATEGIZING. Coach Helen Sandford is seen conferring with the team during a break in the action. Prior to coaching, Sandford taught physical education and was the school's cheerleading advisor. Sandford said that the intramural program gave her early varsity teams some experience in playing local schools. The first game ever played was against Franklin, a 0-0 tie. The girls' first win came against Laurens 1-0. It was only the beginning of 30 seasons in the Sandford era. (Courtesy of Helen Sandford.)

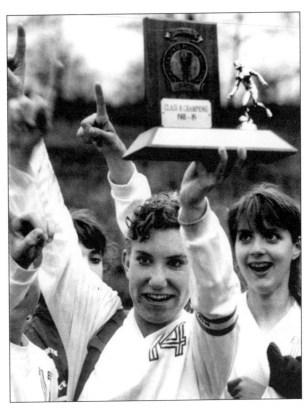

ALWAYS CONTENDERS. Just as with the boys' teams, the playoff structures were different in the early years, as there were no state championships. However, in her 30 seasons, Sandford won 15 sectional championships and 12 league championships in both the STAC and former Susquenango Association. In more recent years, Oneonta High has always gone deep into the playoffs for the state championship but unfortunately has fallen short each time. Seen here is the 1988 team with another addition to the school's trophy cases. (Courtesy of the Oneonta School District.)

HISTORIC ONEONTA COACH. Helen Sandford became the winningest coach in New York State in September 2001, when she passed a Western New York coach who had amassed a 387-76-31 before retiring in 1997. The school hosted a reception for Sandford, and many of her former players returned for the occasion. The new record to beat is now 440 victories. (Courtesy of Helen Sandford.)

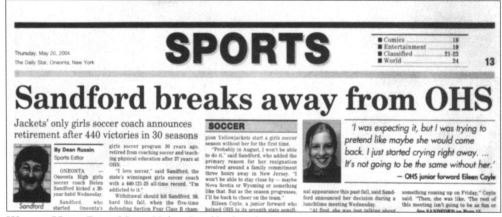

WOULD HAVE BEEN NICE. Helen Sandford said not winning a title was a disappointment. But she said when she looks around at other coaches who have not won a state title, she is in pretty good company. The inevitable was finally announced in May 2004, as a new coach took the reigns. A new era began in September. (Courtesy of the Daily Star.)

Five

WHY NOT ONEONTA?

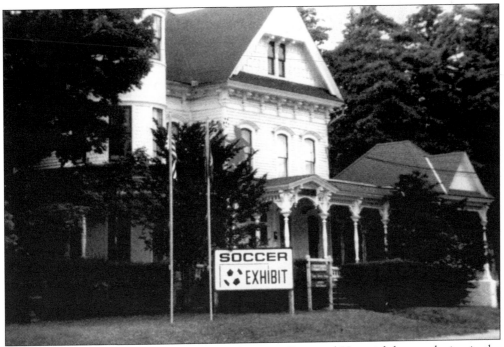

TWENTY YEARS OF SOCCER LATER. Since Oneonta State and Hartwick began playing in the 1950s, soccer continued growing in popularity in Oneonta. With a successful youth program, a near national championship by Oneonta State in 1972, and the Hartwick College title in 1977, some began wondering if the United States had a Soccer Hall of Fame. Yes or no, Oneonta decided to seize the moment. This is the Wilber Mansion on Ford Avenue in 1982. It became the second soccer display, following one in 1979 at Yager Museum at Hartwick College. (Courtesy of the National Soccer Hall of Fame.)

ALBERT COLONE. Although the idea for a museum to honor soccer and its athletes had been suggested for a few years, it was not until 1977 that Mayor James Lettis appointed Albert Colone and a committee to explore the idea of a national museum. Colone had been employed by the city of Oneonta as its director of parks and recreation. The first effort the committee made was to seek official sanctions by various soccer agencies around the country. Initially, these agencies rejected the idea. The committee decided to go ahead with the project anyway. In March 1980, the committee simply proclaimed Oneonta as the location for the National Soccer Hall of Fame. By 1981, the hall got a provisional charter from the state board of regents. Albert Colone was named its executive director, a position he held until 1997. (Courtesy of the National Soccer Hall of Fame.)

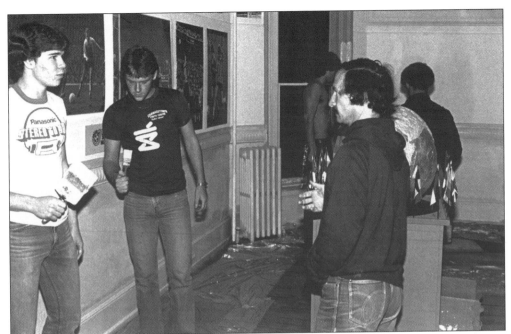

THE PREVIEW SUITE OPENS. The Wilber Mansion was set up as only a temporary site for the hall and opened in 1982. Colone and a new board of trustees had bigger dreams to pursue. Here, former Hartwick College coach Jim Lennox and a few of his players help in preparing the space and exhibits. In its first year, the museum attracted about 2,500 visitors and was open three days a week. (Courtesy of the Paul F. Cooper Jr. Archives at Hartwick College.)

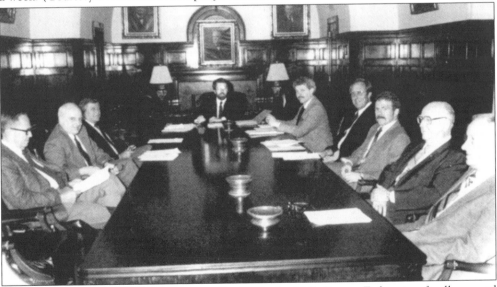

MEET THE DEVELOPMENT COMMITTEE. By 1983, the U.S. Soccer Federation finally named Oneonta as the site for the Hall of Fame. Funding needed to be pursued and plans drawn to make a bigger museum with an outdoor soccer campus of fields and a large stadium a reality. Pictured, from left to right, are Clyde Wright, Robert Moyer, Peter Dokuchitz, Brian Wright (chairman), Albert Colone, Ben Nesbitt, John Biggs, Wilmer Bresee, and D. K. Lifgren. (Courtesy of the National Soccer Hall of Fame.)

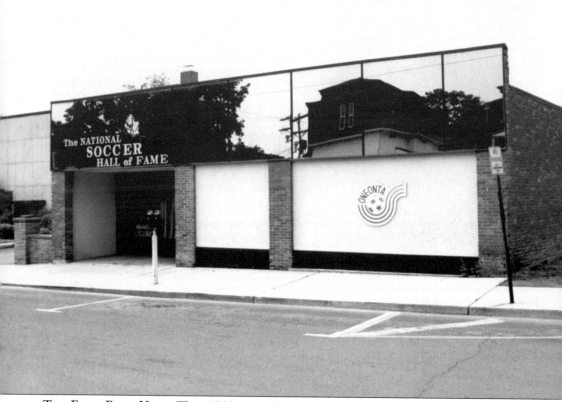

THE FIRST REAL HALL. This 4,000-square-foot museum next to Wilber Mansion opened in 1987. At one time it was a supermarket. In the years leading up to the opening, the development committee got a grant from the Private Industry Council to hire a public relations director, a museum registrar, a soccer activities coordinator, and an office manager. An architectural firm developed a model for the future soccer campus. In 1986, the Soccer Hall of Fame got its first grant from the New York State budget. (Courtesy of the National Soccer Hall of Fame.)

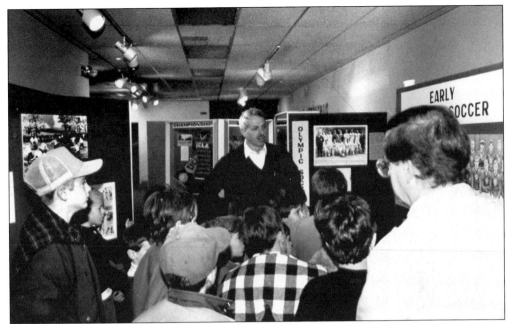

A Personal Welcome. Executive director Albert Colone greets a group of students at the new hall to give a tour. After having only 1,600 square feet to work with in the Wilber Mansion, this new location contained many more exhibits. Administrative offices and a conference room remained in the Wilber Mansion. (Courtesy of the National Soccer Hall of Fame.)

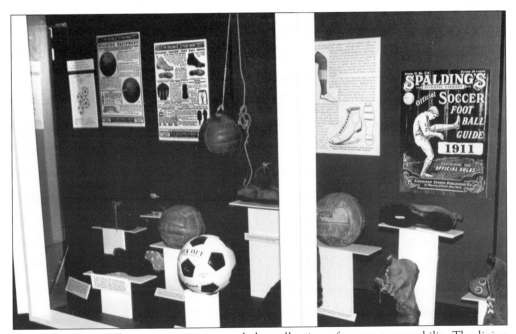

Early Displays. The new museum compiled a collection of soccer memorabilia. The living Hall of Fame members were contacted, and items were either loaned or donated to the museum for display. Initially there were around 10 display cases when the new museum opened. (Courtesy of the National Soccer Hall of Fame.)

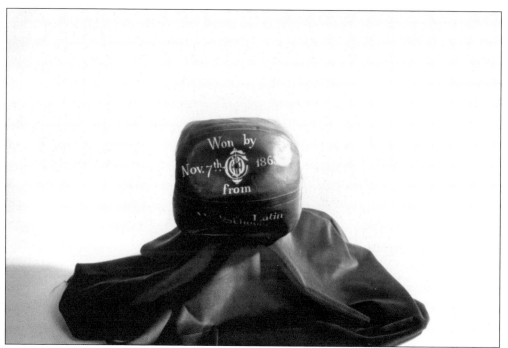

THE COLLECTION GOT BIGGER. Archives at the Soccer Hall of Fame gradually grew into the largest soccer collection in the world, including the world's oldest soccer ball (above), on loan from the Federation Internationale de Football Association (FIFA) Museum. The ball is from a game played in 1855 in Massachusetts. Other collections (below) came from the North American Soccer League, the World Cup USA 1994, plus the John Albok, Sam T. N. Foulds, and Kurt Lamm collections among its thousands of documents and artifacts. (Courtesy of the National Soccer Hall of Fame.)

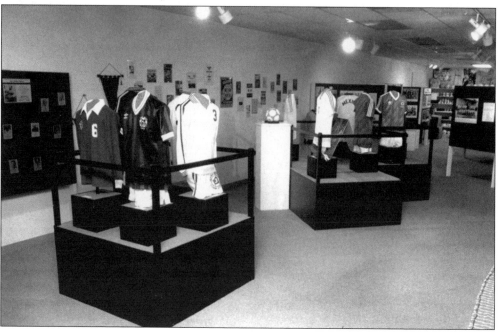

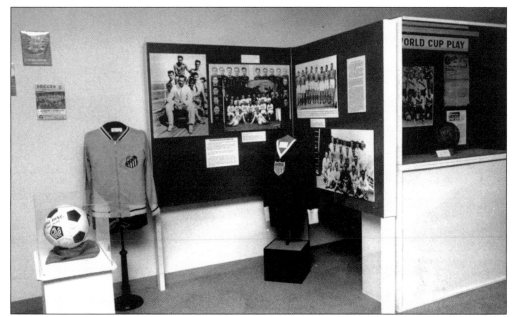

STEPPING UP THE MARKETING PLAN. While visitors to the Hall of Fame slowly increased, there needed to be more awareness beyond the region that such a museum existed. Additional displays are seen above, and below is the museum's gift shop. Hall of Fame officials aimed to raise public awareness of the hall, encourage membership, and get more people interested in its sponsored activities. The hall received an award of over $81,000 in the late 1980s from the New York State Urban Development Corporation to help create that awareness. A sports marketing firm was hired to seek national corporate sponsorship to link to local soccer events. (Courtesy of the National Soccer Hall of Fame.)

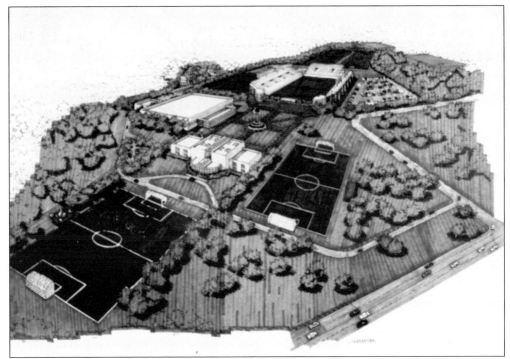

ALWAYS DREAMING BIGGER AND BETTER. While the Ford Avenue museum was sufficient, the archives continued to grow. Activities related to soccer were increasing in Oneonta. An architectural firm had developed this initial model for a soccer campus to be home to a much larger museum, soccer fields, and a stadium. This plan was originally developed in 1985 and was revised a few times. The big question became, Where would this campus be located? (Courtesy of the National Soccer Hall of Fame.)

THE WRIGHT LOCATION. In 1989, due to the generosity of Clyde and Brian Wright and the insight of D. K. Lifgren, a 61-acre plot was purchased in the town of Oneonta, just west of the city. This was the beginning of the Wright Soccer Campus, where four state-of-the-art playing fields would be constructed. The opening of a larger museum at the site was still 10 years down the road. (Courtesy of the National Soccer Hall of Fame.)

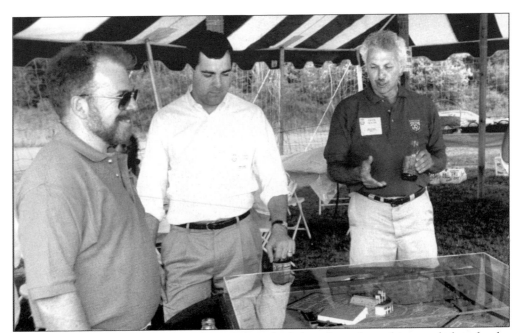

ALWAYS PROMOTING THE PLAN. Albert Colone (right) explains the architectural plans for the Wright Soccer Campus to guests at a reception on the new site. Also shown is Hall of Fame board member John Biggs (far left). Since 1979, Colone had been pitching a soccer complex plan, beginning with the state assembly's committee on tourism, sports, and the arts, as well as countless other organizations. (Courtesy of the National Soccer Hall of Fame.)

THE WORK BEGINS. Bulldozers and other equipment from the U.S. Army National Guard clear land along state Route 205. Cost of the land purchase was $500,000. For 12 days in November 1989, the military exercise moved dirt and tree stumps. The U.S. Army National Guard's work meant an approximate saving of over $300,000 for the Hall of Fame. (Courtesy of the National Soccer Hall of Fame.)

FIELDS TAKING SHAPE. Better access to the new campus was attained when Browne Street was extended to connect with Route 205. With the building of these fields, the intent was to draw visitors for national and international exhibition matches. The irrigation system is being installed (above), with additional work completed by the Clark Companies of Delhi. The aerial view below shows the four fields near completion, with a center area planned for concessions and a plaza. The Wright National Soccer Campus was officially opened in 1990. (Courtesy of the National Soccer Hall of Fame.)

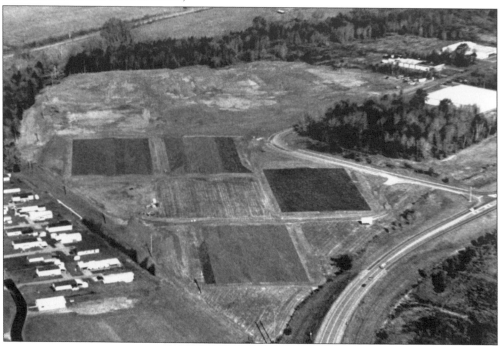

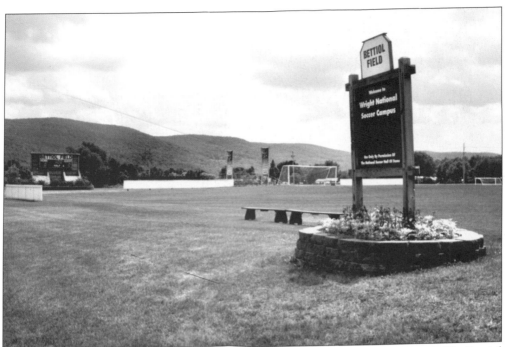

THE NAMING OF THE FIELDS. This field was named after Eugene Bettiol Sr. in 2002. The Bettiol family has been a strong supporter of the Hall of Fame for several years. Eugene's late son, Gene Jr., served on the hall's board of directors. (Courtesy of the National Soccer Hall of Fame.)

EUGENE BETTIOL SR. At the 2002 Hall of Fame induction ceremonies, Bettiol came to hear his granddaughter Carleigh sing the national anthem for the opening ceremony. Instead, it turned out to be a rendition of "Happy Birthday," and an unveiling of the scoreboard and dedication of a field in his name. (Courtesy of the National Soccer Hall of Fame.)

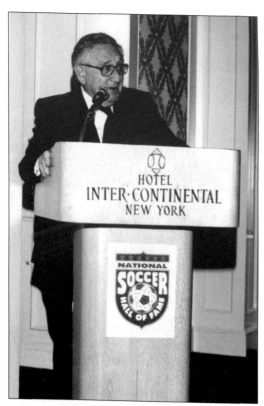

A FAMOUS FRIEND OF THE HALL. Henry Kissinger, former secretary of state and Nobel Peace Prize recipient, became a member of the National Soccer Hall of Fame national board of directors in 1994. Kissinger is speaking at a presentation of the National Soccer Medal of Honor Award to Alan Rothenberg for his work with U.S. Soccer and the World Cup in 1994. (Courtesy of the National Soccer Hall of Fame.)

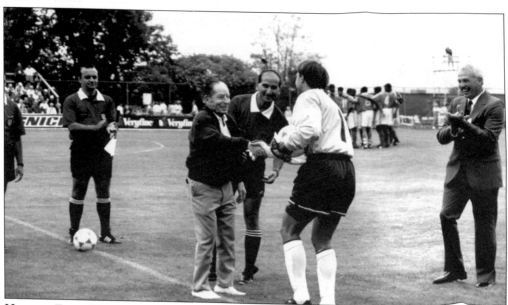

HALL OF FAME WEEK. Before the fields were built at the Wright Campus, Hall of Fame games were played at other sites, such as Elmore Field at Hartwick College. Hall of Famer Phil Sloan (left) shakes hands with U.S. National Team member Kasey Keller at the 1996 Hall of Fame Game. The game has always been part of the festivities surrounding the induction of new members to the hall. (Courtesy of the National Soccer Hall of Fame.)

LOCAL LEGENDS PLAY HALL OF FAME GAME. Former Hartwick College star Glenn Myernick (No. 5) and Oneonta State All-American Alex Brannan are in action for Team Diadora against former New York Cosmos members in a Hall of Fame Game during the 1990s. (Courtesy of the National Soccer Hall of Fame.)

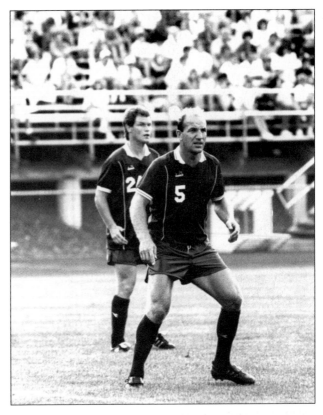

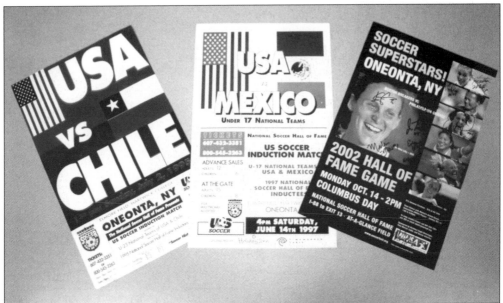

HALL OF FAME GAMES ATTRACT MANY TEAMS. A collection of posters shows samples of the many teams that have played in Oneonta during Hall of Fame Week activities. Due to the number of fans in attendance at these and other games, the Wright fields were not used for Hall of Fame Games until after 2000.

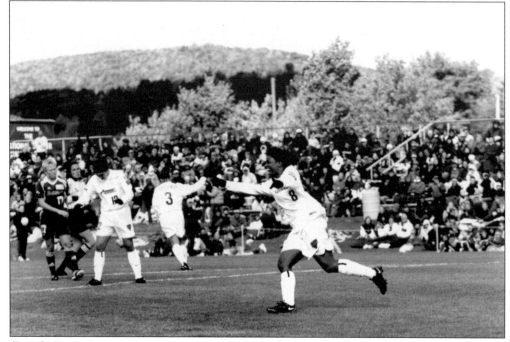

THE GAME IS PLAYED ON CAMPUS. In 2001, the Boston Breakers and Washington Freedom played on a field that the hall arranged to accommodate up to 3,500 spectators. The WUSA contest featured Washington's Mia Hamm and Boston's Kristine Lilly. The game capped the festivities for Hall of Fame Induction Weekend. (Courtesy of the National Soccer Hall of Fame.)

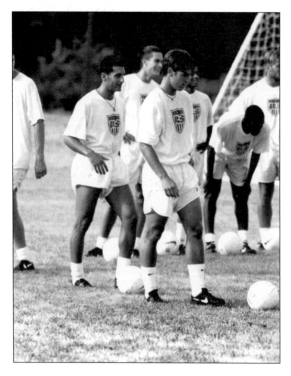

NEW FIELDS GET PLENTY OF USE. The first tournaments on the Wright Soccer Campus began in 1991. In 1992 alone, 231 teams played in tournaments there. Other special guests came to practice, including the U.S. Olympic team, seen here. (Courtesy of the National Soccer Hall of Fame.)

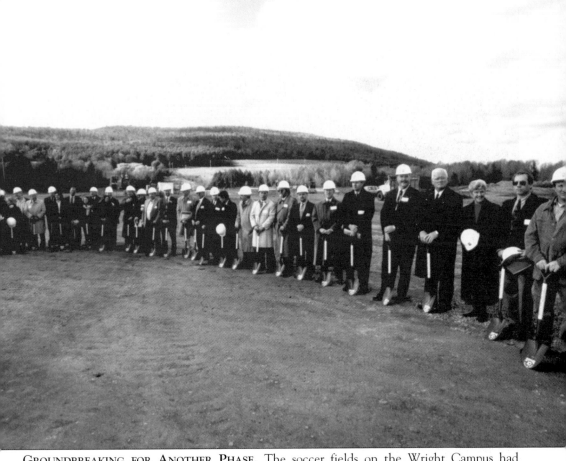

GROUNDBREAKING FOR ANOTHER PHASE. The soccer fields on the Wright Campus had helped greatly in the Soccer Hall of Fame's efforts to bring tournaments and attention to Oneonta and obtain new support from around the globe. Seen here are groundbreaking ceremonies on November 9, 1998. The new museum project began back in 1995 with the awarding of a $4.5 million grant from the state of New York to begin design and development of the National Soccer Hall of Fame complex in Oneonta. In 1998, the U.S. Soccer Foundation pledged $1 million toward the new facility, and a major fund-raising campaign was undertaken by the hall's board of directors. That campaign generated the $7.2 million that went toward construction of the first phase of the new National Soccer Hall of Fame. (Courtesy of the National Soccer Hall of Fame.)

LET THE CONSTRUCTION BEGIN. Seen here are John Biggs, Will Lunn, and Chris Spaccone. During the late 1990s, Lunn became the new president and CEO for the National Soccer Hall of Fame. There had been philosophical differences between the Soccer Hall of Fame board and Albert Colone at that time. Lunn had been a consultant for the hall since 1990 and assumed the new duties in February 1997. (Courtesy of the National Soccer Hall of Fame.)

SEN. JAMES SEWARD. An Oneonta native, Seward confers with Will Lunn at the groundbreaking ceremonies. Seward had been instrumental in securing state funds for the Hall of Fame building projects over the years, along with assemblyman Bill Magee and former assemblyman Anthony Casale. (Courtesy of the National Soccer Hall of Fame.)

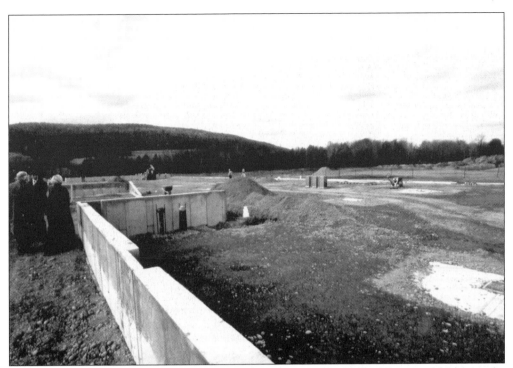

TAKING SHAPE. While the new $8 million, 30,000-square-foot Hall of Fame and Museum was being constructed, the hall on Ford Avenue remained open. Paid museum attendance was on the rise, as there were 3,200 visitors in 1997, and nearly 20,000 visitors in 1999, with an additional 85,000 people visiting the Wright Campus as participants or spectators of events. Local soccer enthusiasts watched the progress on the building, a dream that had been in the works since 1977. Norman Davies, a Binghamton architect, created the dramatic design. (Courtesy of the National Soccer Hall of Fame.)

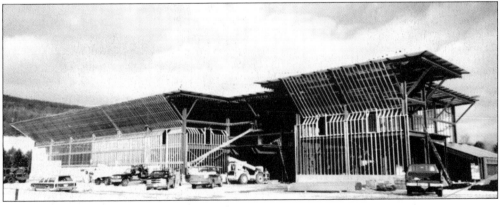

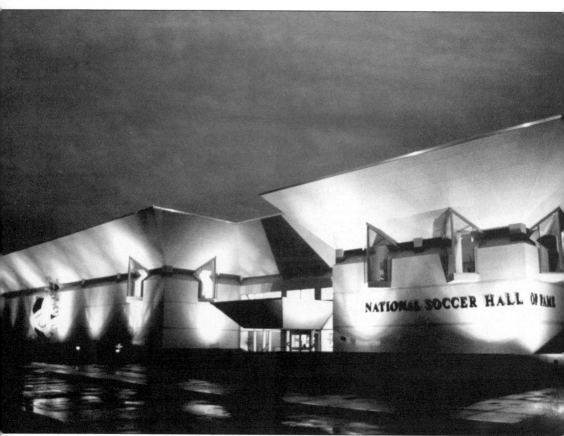

COOPERSTOWN, CANTON, AND SPRINGFIELD HAVE NEW COMPANY. The new National Soccer Hall of Fame and Museum was completed in 1999. For a short time in 1997, it was a possibility that this project would have never gotten off the ground. The Soccer Hall of Fame on Ford Avenue was closed for a short time, due to financial difficulties. Depending on whom you speak to in the area, the change in management and restructuring of the Soccer Hall of Fame board was either positive or negative. Regardless, the building was completed. After the hall's short closure, local donors pulled together to save what had been diligently worked at since 1977. According to new president Will Lunn, over 40 people and businesses made some large contributions to save the hall. Nearly a dozen major gifts of $50,000 or more, and others into six figures, made the difference. (Courtesy of the National Soccer Hall of Fame.)

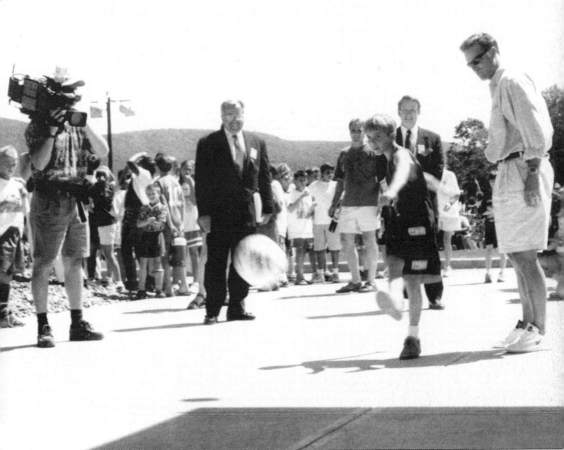

A LESS THAN TRADITIONAL OPENING. Normally, a new building is opened with a ribbon cutting. This was not the case at the new Soccer Hall of Fame and Museum opening on June 12, 1999. Here a youngster takes a shot at putting a soccer ball through the front door to the new building. Directly behind the boy is Jim Hamilton, then chairman of the U.S. Soccer Foundation. To the left of Hamilton is Hank Steinbrecher, the secretary general of the U.S. Soccer Federation. Eric Wynalda (right) is a new inductee to the Soccer Hall of Fame who played for the U.S. Men's National Team during the 1990s. Other youngsters, Hamilton, Steinbrecher, and Wynalda took their shots to open the building. (Courtesy of the Daily Star.)

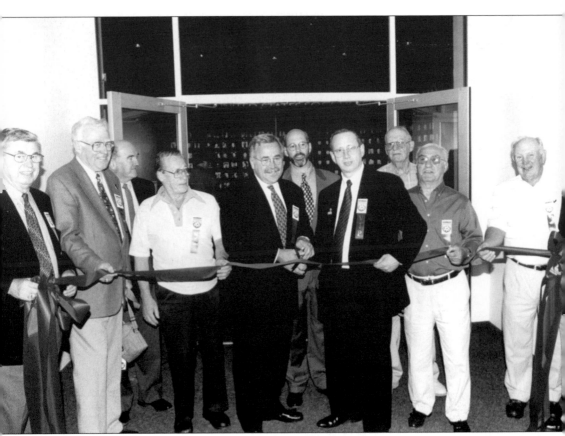

The More Traditional Approach. A number of living Soccer Hall of Famers joined U.S. Soccer Federation officials and other dignitaries on opening day at the new building for a ribbon cutting to the rotunda, which has the names and information of all inductees. Soccer Hall of Fame president Will Lunn is at the center. (Courtesy of the Daily Star.)

THE BUILDING SPEAKS FOR ITSELF. Such was one remark made by president Will Lunn at grand opening ceremonies for the building. People's reception to the building and grounds was overwhelmingly positive. (Courtesy of the Daily Star.)

DOUG WILLIES. A Soccer Hall of Fame board member, Willies addressed the crowd about how the hall will have a significant impact on many lives, and the economy of this area. Willies was president of the At-a-Glance Group of Sidney at the time, and he has since retired. The hall's boardroom was named in Willies' honor. (Courtesy of the Daily Star.)

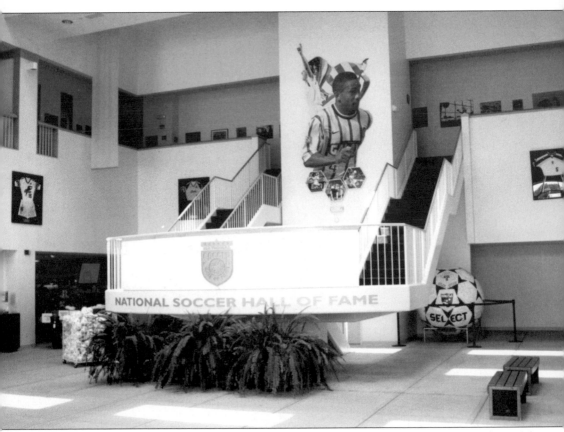

THE GRAND ENTRANCE. This is the sight that greets visitors as they enter the front door of the hall. The giant soccer ball to the right has hundreds of signatures on it. The area at the foot of the two staircases is where annual induction ceremonies are held. Offices are located upstairs, as well as the boardroom.

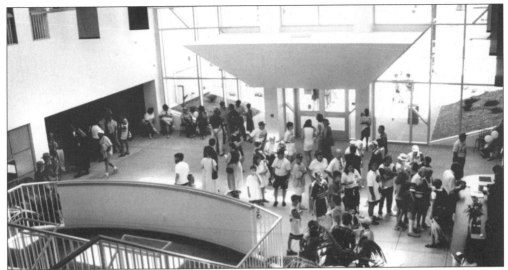

GET YOUR TICKETS HERE. On opening day, while 1,000 people were estimated at the opening ceremonies, more than 5,000 passed through the museum gates. More than 20,000 annual visitors have consistently passed through the gate in recent years, not counting those attending tournaments and games. Before people began lining up, Sen. James Seward, in his address at opening ceremonies, said, "Today we proved that dreams can become a reality. What a great day for our area, for our economy, for soccer and for our collective future." (Courtesy of the Daily Star.)

JASON RAIZE. There were not just speeches at the opening ceremonies. Raize, an Oneonta High School graduate, entertains the crowd. Raize was appearing in the Broadway production of *The Lion King* at that time. Behind Raize is town of Oneonta supervisor Duncan Davie. (Courtesy of the Daily Star.)

DIDN'T REQUIRE A PARKING SPACE. It was not in the formal plans for opening day, but these guests decided to pay a visit in a nontraditional fashion. (Courtesy of the Daily Star.)

TONY MEOLA. The veteran goalkeeper for the U.S. National Team addressed the crowd. Meola described the new hall this way: "Awesome—there's no other word to describe this place." Mary Harvey, the starting goalkeeper for the U.S. Women's National Team described the Hall as a "player's hall." (Courtesy of the Daily Star.)

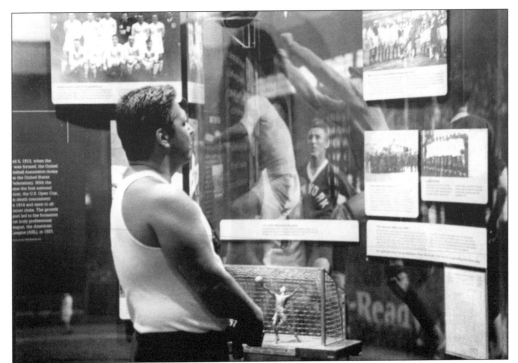

JUST BROWSING. This opening day visitor learns about the early history of soccer in the United States. In addition to the many displays, visitors to the Hall of Fame can take advantage of a research library. (Courtesy of the Daily Star.)

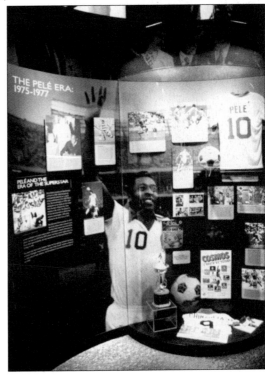

THE WORLD'S MOST FAMOUS SOCCER PLAYER. Not only is he enshrined in the Soccer Hall of Fame, Pelé is honored in this permanent display at the museum. Pelé was most remembered for his playing for the New York Cosmos of the former North American Soccer League.

MARCELO BALBOA. One of the most consistent defenders for the U.S. Men's National Team, Marcelo Balboa made a name for himself at the 1994 World Cup with outstanding defensive performances. Balboa and the rest of the men's national team showed a renewed dedication to American soccer on the world level, competing in the World Cup in 1990 for the first time in 40 years. (Courtesy of the National Soccer Hall of Fame.)

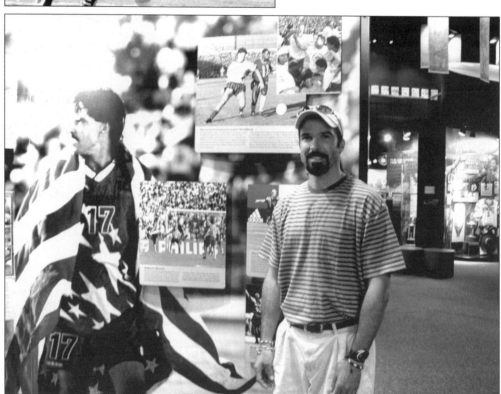

MARKING THE MOMENT. Marcelo Balboa stands near a display in his honor at the National Soccer Hall of Fame. (Courtesy of the National Soccer Hall of Fame.)

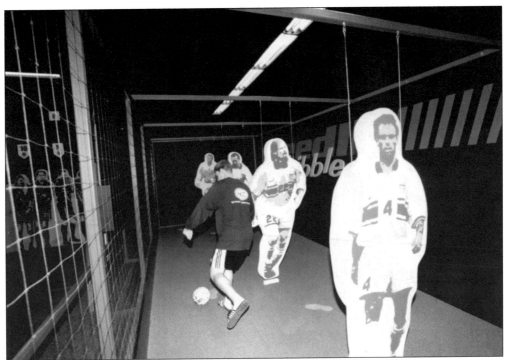

BRING YOUR SNEAKERS TO THIS MUSEUM. One of the features of the Soccer Hall of Fame is a "feet on" experience, especially for youngsters. Above, a boy dribbles the ball around some images of defenders in the Kicks Zone. Some youngsters play on a miniature field to test their skills (below). Participants also see and hear the little-known, fascinating stories of soccer. (Courtesy of the National Soccer Hall of Fame.)

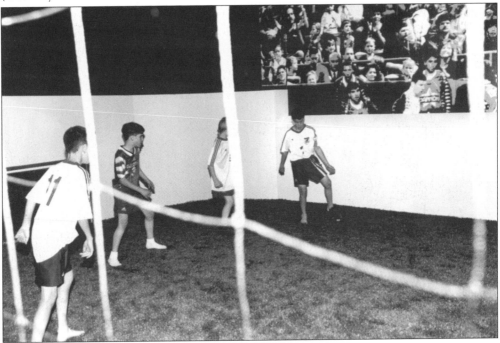

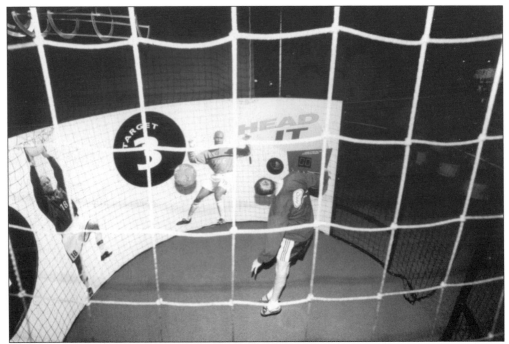

MORE TO DO, MORE TO SEE. Another interactive experience at the hall is to head a soccer ball. The entire museum was designed to be interactive, in addition to informational. The hall also has an attractive souvenir and gift shop, seen below. (Courtesy of the National Soccer Hall of Fame.)

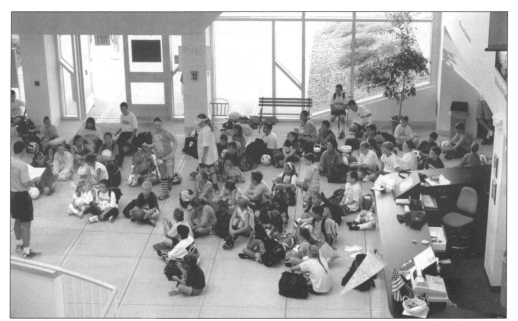

AN INSTRUCTIONAL PLACE. On occasion, the Soccer Hall of Fame also gives instructional clinics and workshops to youth in the region. Here, a group is taking in some advice by an instructor and will soon go outside to the playing fields to work on their skills. (Courtesy of the National Soccer Hall of Fame.)

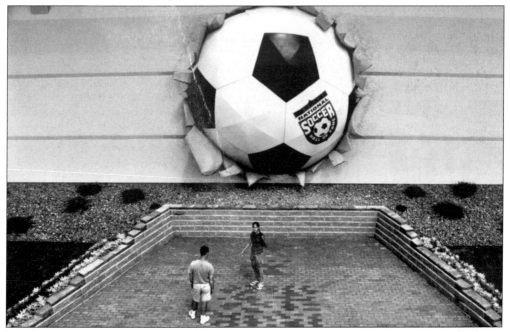

THE WALK OF FAME. Another intriguing bit of architecture at the Hall of Fame is this giant ball, which appears to be smashing through the wall. Below it, a couple looks over bricks with names on them. A friend of the Hall of Fame can purchase a brick and have their name inscribed on it, which is then placed in this walk. This area of the museum is a popular place for visitors to pose for photographs. (Courtesy of the National Soccer Hall of Fame.)

THE FIRST LADY VISITS. Shortly after the new building opened in 1999, First Lady Hillary Rodham Clinton visited the Hall of Fame while in the area. Clinton and Will Lunn walk to the site of the giant soccer ball near the Walk of Fame, where Clinton unveiled the ball to the public for the first time. Clinton went on to become senator for New York State. (Courtesy of the National Soccer Hall of Fame.)

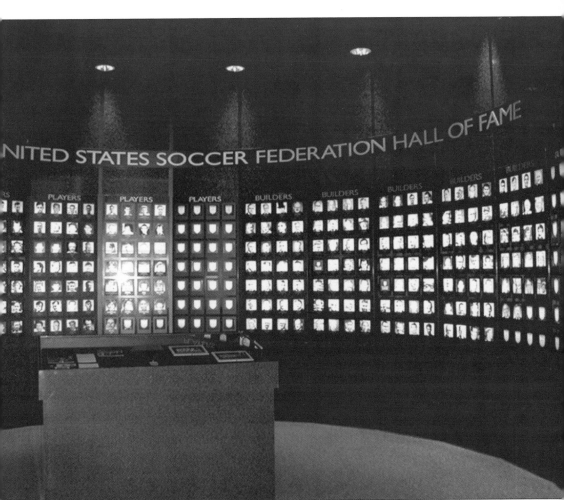

THE ROTUNDA. This is where all of the U.S. Soccer Federation Hall of Fame inductees from 1950 to the present are enshrined. The players in the hall are those who have contributed the most to the sport of soccer. Builders are the owners, team management and administrators, coaches and trainers who have made a major impact on "the Beautiful Game." Inductees are elected by a selection committee consisting of former national team coaches and players and the U.S. soccer media via the Professional Soccer Reporters Association. (Courtesy of the National Soccer Hall of Fame.)

WORN ONLY BY THE BEST.
Each Hall of Fame inductee
gets a ring. A retired player
can be selected four years after
their last appearance. They
need to have played at least
five seasons in a first division
U.S. professional league, with
an All-League nomination, or
have been an outstanding U.S.
National Team player based on
performance and appropriate
number of international
appearances. (Courtesy of the
National Soccer Hall of Fame.)

GEORGE BROWN. Seen here at play with the ASL All-Stars at Ebbets Field in 1957, Brown, a
resident of Greater Oneonta, was inducted into the hall in 1995. Brown played in the 1959
Pan-Am games, and the bronze medal won that year by the U.S. team has been placed in the
hall's collection, along with his father's 1930 World Cup medal. George and his wife, Peg, are
regular volunteers at the hall, cataloguing artifacts and memorabilia in the museum's archives.
(Courtesy of the National Soccer Hall of Fame.)

TWO MEMBERS AT PLAY. Jack Hynes (left) of the New York Americans and Gene Olaff of the Brooklyn Hispano were opponents in 1948. Hynes, inducted into the hall in 1977, was selected in 1949 to the U.S. National Team to play in the World Cup qualifying competition in Mexico against Mexico and Cuba. Olaff, inducted in 1971, also played for the U.S. National Team in 1948 against Israel and in 1949 against Scotland in New York. (Courtesy of the National Soccer Hall of Fame.)

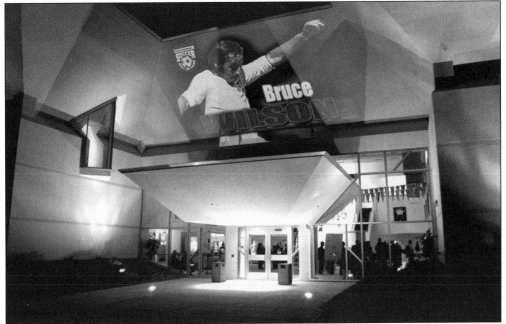

A SCENE FROM INDUCTION NIGHT. Soccer enthusiasts from near and far are gathered in the main entrance area of the Soccer Hall of Fame as new members are inducted. It is part of a weekend of soccer activities, including a Hall of Fame Game. (Courtesy of the National Soccer Hall of Fame.)

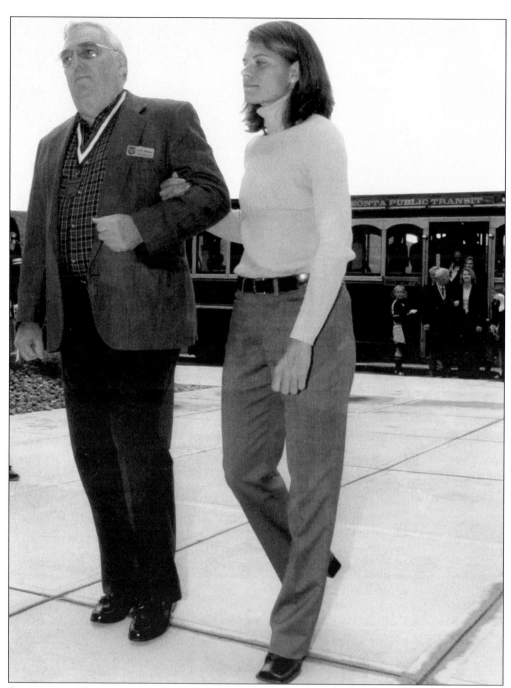

STARS FROM YESTERDAY AND TODAY. Hall of Famer Lloyd Monsen escorts Mia Hamm into the Hall of Fame for induction ceremonies in 2001. Monsen was inducted in 1991. Hamm was in Oneonta, as she and her Washington Freedom played the Boston Breakers in the Hall of Fame Game. The induction ceremony was kicked off by the arrival of returning Hall of Famers, such as Monsen, who disembarked from the Spirit of Oneonta, a motorized turn-of-the-century trolley, and entered the hall, two by two, to thunderous applause. (Courtesy of the National Soccer Hall of Fame.)

MORE STARS ARRIVE. Hall of Famer Raymond "Granny" Kraft and 1991 U.S. Women's National Team member Julie Foudy enter the hall for the 2001 induction ceremonies. Kraft, a 1984 inductee, was a FIFA referee for many international matches in the 1950s and 1960s. Foudy was co-captain and a nine-year veteran of the U.S. Women's National Team and a member of the gold-medal-winning U.S. Women's National Team at the 1996 centennial Olympic Games. (Courtesy of the National Soccer Hall of Fame.)

GLORY DAYS. Another event surrounding Induction Weekend is the Liars' Retreat, where returning Hall of Famers gather to tell all kinds of soccer stories, some of which, they joke, may have been true. Former players in their 30s through 80s have met since 2000 for this afternoon of camaraderie and reminiscing. (Courtesy of the National Soccer Hall of Fame.)

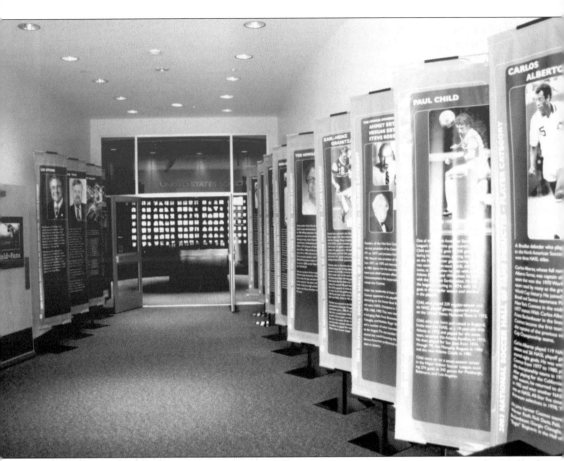

IN THE SPOTLIGHT FOR A YEAR. Each year after a new round of inductees enters the Hall of Fame, these banners are displayed as one enters the Hall of Fame Rotunda area. These represent the inductees for 2003. Inductions are now held each October. (Courtesy of the National Soccer Hall of Fame.)

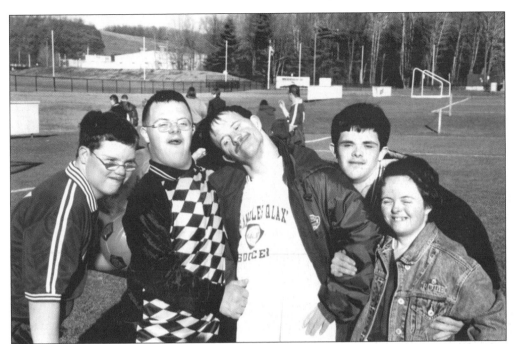

THE HALL HOSTS GOOD FRIENDS. Seen here are members of a Special Olympics team from Pathfinder Village in Edmeston. The Hall of Fame occasionally hosts the team for practices. The hall has also begun holding clinics for those with other disabilities. (Courtesy of the National Soccer Hall of Fame.)

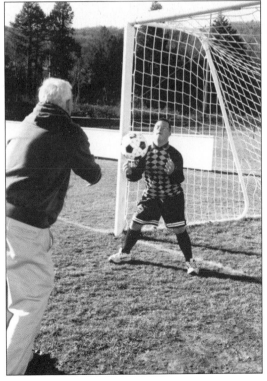

TEACHING STRATEGY AND GOOD SPORTSMANSHIP. Hall of Famer George Brown is shown giving the Pathfinder Village Special Olympics goalie some pointers. Brown and his wife, Peg, volunteered to coach the team. They have a niece with Down syndrome, and they became involved with Special Olympics after visiting Pathfinder Village. (Courtesy of the National Soccer Hall of Fame.)

MORE THAN JUST SOCCER. The Hall of Fame has become an art gallery in recent times. This is a display of paintings by Canadian Hall of Famer Carrie Serwetnyk. The exhibition marked the hall's celebration of the National Girls and Women in Sports Day, which is in February. Serwetnyk played for the University of North Carolina, the Canadian National Team, as well as in women's professional leagues in France and Japan. (Courtesy of the National Soccer Hall of Fame.)

HALL OF FAME CARS AT THE HALL. The Soccer Hall of Fame hosts the annual Oneonta Reminiscers Car Club Show, held each year on Father's Day. Seen here are only a few of the nearly 200 vintage vehicles that were on display on the hall's grounds. (Courtesy of the National Soccer Hall of Fame.)

MUSIC IN THE MUSEUM. The hall has also hosted musical events in its various rooms in the museum. This festival had three different stages, with the main stage in the museum, another in the atrium, and one in the vending area. This photograph shows a band from the first concert in 2004, where the entertainment included Bluegrass, Celtic, and Cajun music. (Courtesy of the National Soccer Hall of Fame.)

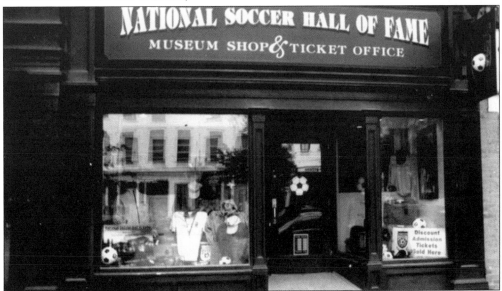

PRESENCE IN ANOTHER HALL OF FAME TOWN. This museum shop and ticket office opened during 2002, almost directly across the street from the National Baseball Hall of Fame and Museum in Cooperstown. It was a marketing initiative to tap into the rich tourist market and encourages visitors to make the visit to Oneonta, less than a half-hour away. (Courtesy of the National Soccer Hall of Fame.)

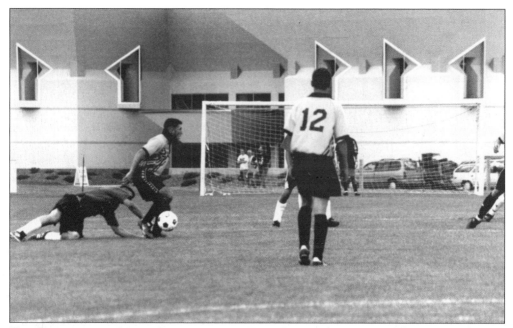

THE ROAD TO THE STATE CHAMPIONSHIPS ENDS HERE. The Soccer Hall of Fame is host to several playoff games on their fields during October and November. Boys' and girls' teams from the Tri-Valley League, the New York State Public High School Athletic Association, finals for the State University of New York Athletic Conference, and more become champions or runners-up here. (Courtesy of the National Soccer Hall of Fame.)

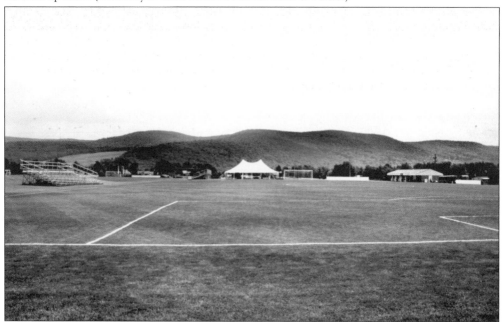

PLENTY OF ROOM TO PLAY. There are four fields available for tournaments, through special request. Three of the fields are named, including Bettiol, Wilber National Bank, and At-a-Glance, due to substantial financial support from these businesses. The fields surround a festival tent and concession area. (Courtesy of the National Soccer Hall of Fame.)

ROOM FOR GROWTH. The construction of the hall on the 61-acre campus was designed to allow for expansion. The side of the building that is flat was intentionally left that way for future growth. Plans exist for a stadium to be built within the next few years where the mound and the rest of the vacant land can be seen.

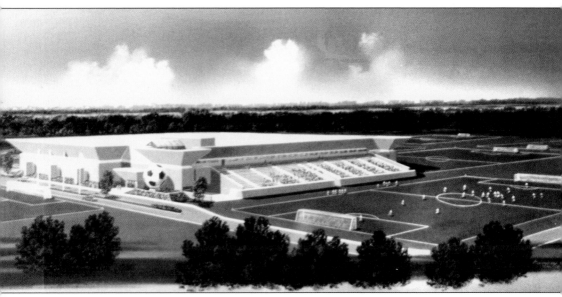

THE NEXT PHASES. An architectural drawing of a proposed stadium is seen here. Such a stadium has been a dream of the Soccer Hall of Fame since the late 1970s. Additionally, the hall's master plan called for four additional playing fields, an indoor arena, and a dormitory called the Hall of Fame Village. The aim is to make the Hall of Fame a year-round facility. Fund-raising continues. (Courtesy of the National Soccer Hall of Fame.)

Six

SOCCER IN THE COMMUNITY

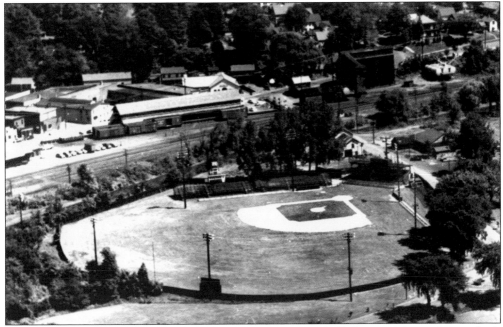

DAMASCHKE FIELD. Although the field appears as a baseball diamond here, the pitcher's mound was flattened and the bleachers were moved so the field could be used for football and, especially in the 1970s, for soccer. Probably the most visible soccer event in the community began in September 1976, with the first Mayor's Cup Tournament.

THE MAYOR'S CUP HIGHLIGHTED LOCAL TALENT. From high school to college, the tournament brought in teams from near and far. Oneonta State and Hartwick College have always played the tournament, as have teams from Oneonta High School. Seen here is the former "graffiti building" on the grounds of Oneonta High School, which frequently cheered on the home teams. (Courtesy of the Oneonta City School District.)

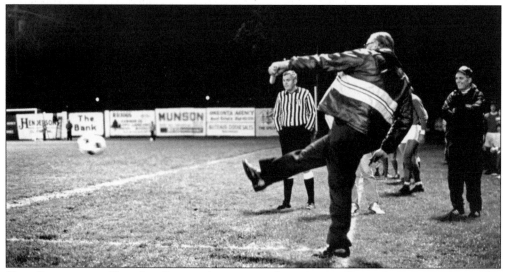

THE CEREMONIAL KICK-IN. Oneonta's mayor at the time was James Lettis, seen here. The tournament began through the city of Oneonta's recreation department. The concept was produced by the director of the department, Albert Colone, along with Joseph Bernier and Mayor Lettis. The tournament was perceived as the kickoff to the fall sports season. (Courtesy of the Daily Star.)

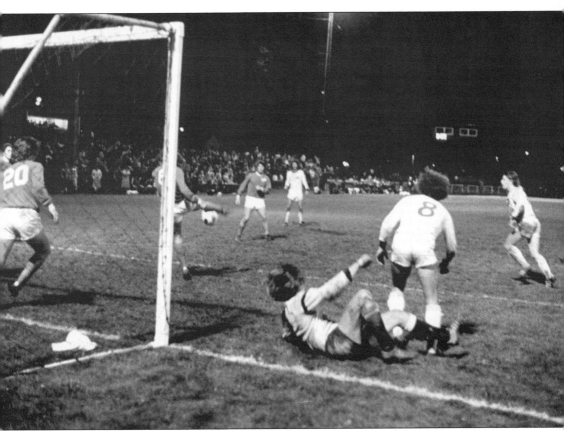

THE FIRST MAYOR'S CUP. While Oneonta State and Hartwick College were the host teams of this event, the idea was to bring in two other nationally competitive teams. In 1976, the visiting teams were from Bucknell University and the University of Southern Illinois-Edwardsville. Thousands of spectators filled the bleachers at Damaschke Field on Friday and Saturday night to see some close contests. Hartwick is seen here in the all-white uniforms. Oneonta State took third in the tournament, beating Bucknell in the consolation match 2-1. Hartwick College was sparked by Glenn "Moochie" Myernick's domination of the backfield, and they came from behind to beat Southern Illinois 2-1. (Courtesy of the Daily Star.)

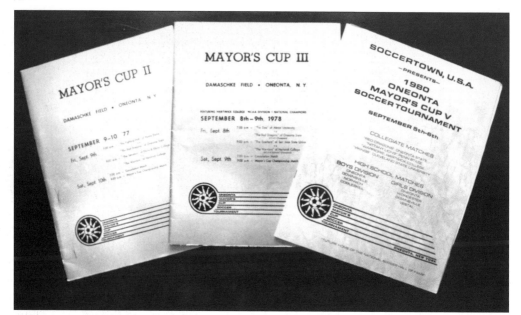

A Collection of Early Cup Programs. As one can see, the talent level of high school and Division I colleges that came to play at Mayor's Cup never waned. Through 2002, only 11 visiting teams have won the tournament. Cleveland State achieved it twice, in 1979 and 1980. (Courtesy of Alex Brannan.)

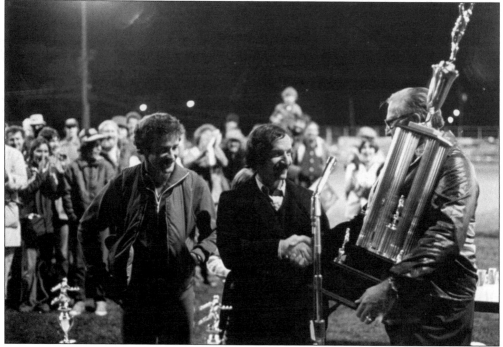

The Awards Ceremony. Mayor James Lettis shakes the hand of Hartwick College coach Jim Lennox and hands him the Mayor's Cup. The trophy remains on permanent display at the National Soccer Hall of Fame, and it is updated annually. The winning schools now receive smaller trophies they can display in their own trophy cases. (Courtesy of the Daily Star.)

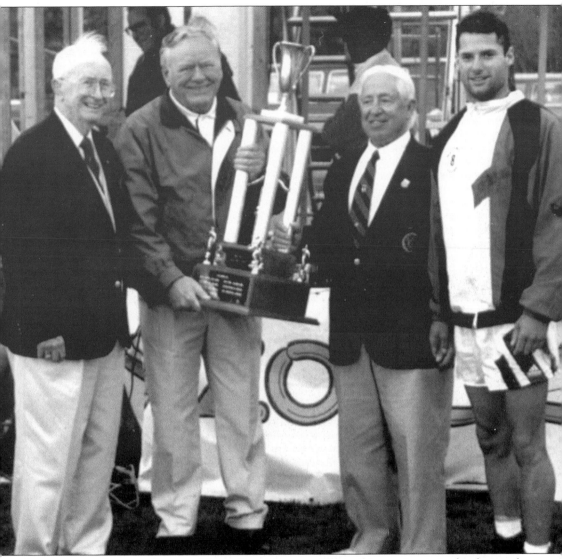

AWARDS AND SPECIAL GUESTS. Mayor David Brenner followed James Lettis in the duties of awarding the Mayor's Cup. Hartwick won this tournament in 1992 against Monmouth University. Through 2002, Hartwick has won the tournament 14 times, and Oneonta State has won it twice. Seen here dressed in suits are Soccer Hall of Famers Gene Ringsdorf (left) and Raymond Kraft (next to a Hartwick player). Kraft, as previously mentioned, was a Hall of Fame referee. Ringsdorf was inducted into the hall in 1979 and was president of what was called the U.S. Soccer-Football Association during the 1960s. He was noted for his efforts to advance the cause of soccer in American high schools. (Courtesy of the Sports Information Office at Hartwick College.)

MAYOR KIM MULLER GIVES THE AWARD. Hartwick midfielder Neil McLean is pictured with the mayor after Hartwick won the tournament in 2001. Since the mid-1990s, the Mayor's Cup has expanded into a month-long event with various tied-in activities in the community. The John Biggs Youth Soccer League begins play, and downtown, Oneonta holds its annual grand and glorious garage sale, among other activities. Use of Damaschke Field as the site of the Mayor's Cup was discontinued. The tournament is now generally played at the Wright Soccer Campus fields. Women's soccer games were added to the tournament in 1996. (Courtesy of the Hartwick College Sports Information Office.)

YOUTH SOCCER HAS ALWAYS BEEN POPULAR. Most youngsters of the time recall when Francisco Marcos invited kids to play soccer back in the late 1960s at Neahwa Park. The youth league's leadership was transferred to Joseph Pascale until 1973, when it was taken on by the Oneonta Jaycees. The program was designed to be basically noncompetitive for boys and girls between the ages of 7 and 15. Everyone played and learned. There were no standings, playoffs, or super teams involved. (Courtesy of David W. Brenner.)

THE YOUTH PROGRAM GREW. By the late 1970s, more than 500 boys and girls from around the area participated in the youth program. Today, there are nine fields marked off in Neahwa Park, and participation goes well beyond the earlier numbers. As the program evolved, permanent and longtime commitments were needed. John Biggs, a major area soccer supporter, began to be looked up to as the coordinator of assignments, schedules, and trainer of officials. Eventually the program was named in his honor. (Courtesy of David W. Brenner.)

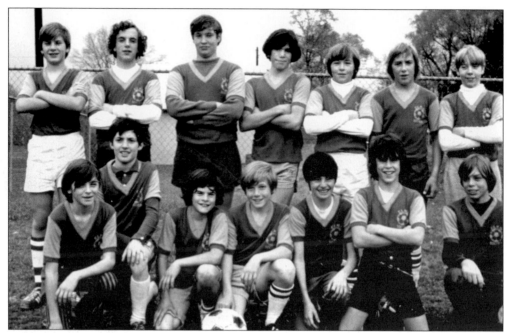

PLAYING SOCCER DEVELOPED CHARACTER AND TEAMWORK. This team had in their ranks several players who went on to become teachers, two police officers, a medical technician, accountants, two college professors, and a physical therapist. Many recall their youth soccer participation with enthusiasm and positive feelings. (Courtesy of David W. Brenner.)

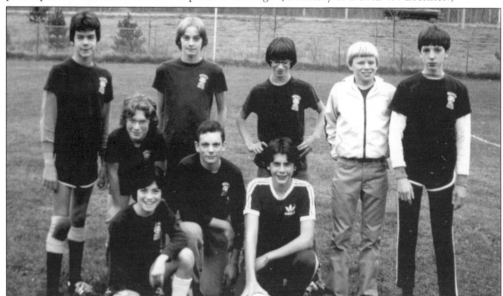

BIGGER AND BETTER. The Oneonta Youth Soccer Program flourished, and commercial sponsors—banks, fuel oil companies, convenience stores, radio stations, dry cleaners, automobile dealerships, and others—signed up as sponsors. It was not unusual to have over 1,000 youngsters playing soccer on a Saturday morning in Neahwa Park. Later, the numbers increased again when Laurens, Worcester, Cooperstown, Jefferson, Milford, and other communities developed teams and secured sponsors. (Courtesy of David W. Brenner.)

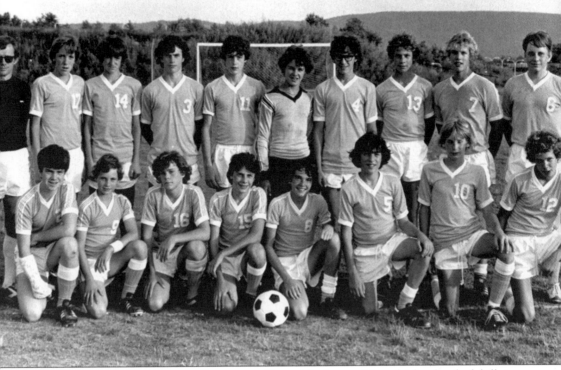

SPIN-OFFS FROM YOUTH SOCCER OCCURRED. To satisfy the need for a higher level of skills in high school, traveling teams were developed from the ranks of the youth program. This was especially true after the program age limits had been reached. This was the first traveling team of boys in 1979, the Oneonta Soccer Club, coached by Corky Lynch. This and other teams have traveled all over the region during its history. At first they played around Broome County. Teams under age 14 played in the Upper Susquehanna League. More recently, the teams play in Albany's capital region. It was the effort of numerous families that made the transportation and food possible for these teams. (Courtesy of Nelson DuBois.)

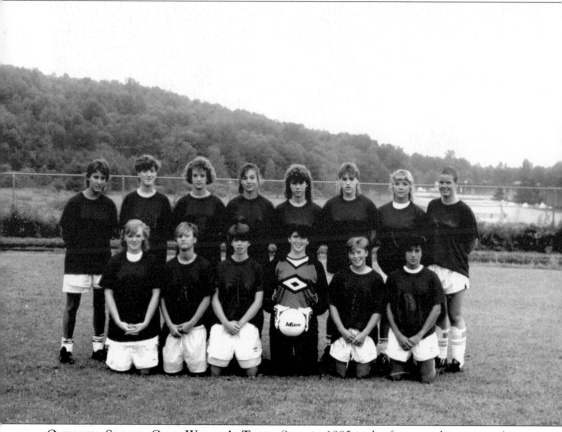

ONEONTA SOCCER CLUB WOMEN'S TEAM. Seen in 1985 is the first traveling women's team. At first, they played in the Upper Susquehanna League. There have been some enormously successful high school girls' coaches who began in this league. Regional high school state girls Class B champions Worcester, Cherry Valley, and Margaretville were coached by Jean Campbell, Frank Miosek, and Dan Cohen, respectively. (Courtesy of Nelson DuBois.)

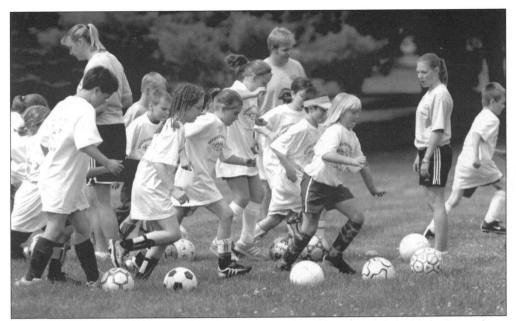

ONE OF MANY YOUTH SOCCER CAMPS. Each summer, youngsters from across the region have had several choices for gaining skills that may not be taught as well in noncompetitive leagues. In past years, there have been camps held at Hartwick College, Oneonta Soccer School, or the Headwaters Soccer Club, among others. (Courtesy of Gerry Raymonda Photography.)

HEADWATERS SOCCER CLUB. This is a nonprofit organization and has been under the direction of Oneonta's Dave Ranieri since 1990. Camps are held in Worcester, Laurens, Otego, and at Mine Kill State Park. This camp gives children in smaller school districts the kind of opportunities in athletics that are not available in larger school districts. (Courtesy of Gerry Raymonda Photography.)

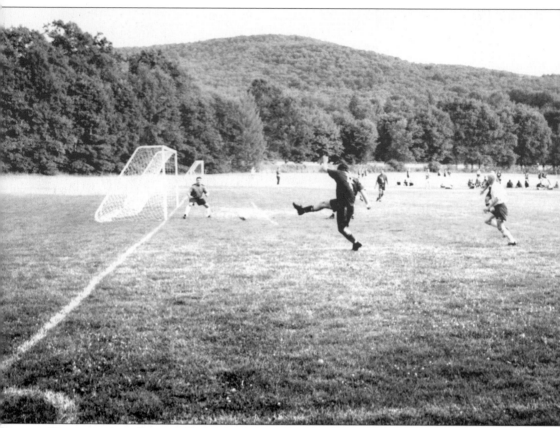

RECREATIONAL SOCCER. For many years, soccer has become something for the grown-ups to enjoy. In fact, a lot of players got their start in youth soccer and still enjoy playing the game. During the spring and summer evenings, these fields at Riverside Elementary School are busy with games, and the players range from their late teens through their forties. Seen at goal is Helmuth Michelitsch, an Oneontan who grew up with youth soccer and played for Oneonta High School. He is currently a Soccer Hall of Fame board member, coaches local youth programs, and has been an avid supporter of soccer in Oneonta.